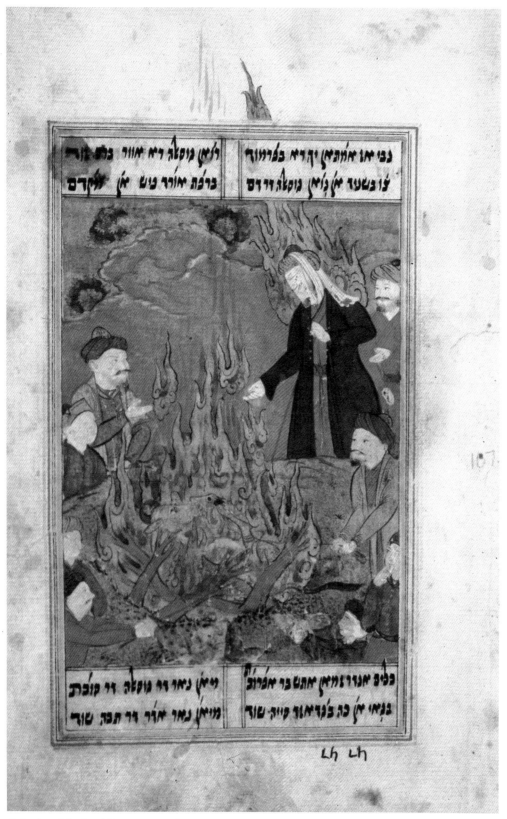

Collection of the Israel Museum, Jerusalem

Bibliographica Judaica 9

Miniature Paintings in Judaeo-Persian Manuscripts

by Vera Basch Moreen

Hebrew Union College Press, Cincinnati 1985

Cover illustration: A large plane tree embraced by three angels represents the uprooting of Shah Ardashīr's garden. Shāhīn's Ardashīr Nāma, SPK or. qu. 1680, fol. 82r

Grants from the following helped to support this publication:

The Society of Jewish Bibliophiles Fund of
 Hebrew Union College-Jewish Institute of Religion
The Henry Englander-Eli Mayer Publication Fund
 established in their honor by
 Esther Straus Englander and Jessie Straus Mayer
The Yarshater Foundation

Library of Congress Cataloging-in-Publication Data

Moreen, Vera Basch.
 Miniature paintings in Judaeo-Persian manuscripts.

 (Bibliographica Judaica, 0067-6853 ; 9)
 Bibliography: p.
 1. Illumination of books and manuscripts, Jewish –
Iran – Catalogs. 2. Illumination of books and
manuscripts – Iran – Catalogs. 3. Jews in art – Catalogs.
4. Jews – Iran – Intellectual life. I. Title.
II. Series.
ND2935.M67 1985 745.6'7'089924055 85-60717
ISBN 0-87820-907-7

The reproductions in this book and on the microfiche are reproduced with the permission of the holding institutions.

Typography and design by Noel Martin
Typesetting by Cobb Typesetting Co., Inc.
Offset lithography by Young & Klein, Inc.
Manufactured in the United States of America

Contents

In memory of
David Tovia Whiteman (וייטמאן), ז״ל
1869-1935
Of the dynasty of the Chernobyl Hassidim

A lineal descendant of Aarel Halevi
who escaped the unforgettable cruelties
of Bogdan Chmielnicki in 1648
and returned to rebuild the Jewish
community and town of Radomyshl
in Western Ukraine

אל תסג גבול עולם אשר עשו אבותיך
Do not remove the ancient boundary stone
That your ancestors set up.
— Proverbs 22:28

This volume is published with the assistance
of a gift from Miss Sarah Whiteman

For our beloved son Gabriel ראשית אוננו

Acknowledgments

This study would be incomplete without acknowledging the aid of the following: The Memorial Foundation for Jewish Culture for awarding a post-doctoral grant enabling me to undertake the research of this subject and the Yarshater Fund for contributing to the costs of publishing this work. I am particularly indebted to the following libraries and their librarians for aid often repeated and generously rendered as well as for permission to publish material in their keeping: Dr. Menachem Schmeltzer, Librarian of the Jewish Theological Seminary of America, New York and his assistant, Mrs. Susan Young; Dr. David Goldstein, Assistant Keeper, Hebrew Section, the British Library, London; Dr. Dieter George, Head of the Oriental Department, Staatsbibliothek Preussischer Kulturbesitz, Berlin; Dr. R. Grafman, Curator, Department of Jewish Ceremonial Art, The Israel Museum, Jerusalem; Dr. M. Nadav, Head of the Department of Manuscripts and Archives of the Jewish National and University Library, Jerusalem; Dr. Jonathan Rodgers, former Head of Special Collections, Klau Library, Hebrew Union College-Jewish Institute of Religion, Cincinnati.

I am greatly indebted to Professor Joseph Gutmann for inspiring this project and for reading this manuscript and making many valuable suggestions. I am also grateful to Rabbi Roy Mittelman for placing his photographic talents at my disposal. In addition, I am happy to acknowledge the aid of my friends Mrs. Tovah Beeri, Professor Amnon Netzer (Hebrew University, Jerusalem), Dr. Howard Kreisel, Mrs. Jeanette Mirsky and my brother-in-law and sister, Professor and Mrs. Andrew H. Plaks (Princeton University), for helping me obtain material from Israel. Thanks are also due to Drs. David T. and Ann Van Zanten (Northwestern University, Evanston, Ill.), to Professor and Mrs. Lawrence Bernstein (University of Pennsylvania) and to Mr. Sidney Becker.

The most enduring source of inspiration for the undertaking of this project was the arduous and interesting work in which my beloved teacher, Martin B. Dickson (Princeton University), and his collaborator, Professor Stuart Cary Welch (Curator of the Islamic Collection at the Metropolitan Museum of Art, New York), have been involved for the last decade, the publication of the magnificent Houghton *Shāh Nāma*. The encouragement of Professors Dickson, Welch and Isadore Twersky (Harvard University) enabled me to persevere in the completion of the project. Above all, I am grateful to my husband Robert for never allowing me to lose sight of my goals.

The publication of this work is made possible by the efforts of Dr. Herbert C. Zafren, Chairman of the Board of Editors of *Bibliographica Judaica*. I am thankful for his advice and help throughout the process of publication. And

for their painstaking editing of my manuscript, I am greatly indebted to his assistants Ms. Arnona Rudavsky and Ms. Laurel Wolfson.

The terms Persia/Iran and Persian/Iranian have been used interchangeably in this study. Persia has been known as Iran officially since 1935. In the course of this study references are made to modern Persian editions of texts whenever possible and to translations when available.

Preface

In recent years the magnificence of Iranian miniature paintings has come to public view through scholarly publications and several exhibits, but a secondary unique group of paintings known as Judaeo-Persian miniatures have remained neglected. Until now scholarly disregard has stemmed, at least in part, from the complexity of dealing with two languages. Judaeo-Persian miniatures illustrate Judaeo-Persian manuscripts which are in the Persian language interspersed with some Hebrew vocabulary and in the Hebrew script. In addition to a thorough knowledge of Persian and Hebrew a proper understanding of the cultural and artistic value of Judaeo-Persian miniatures requires familiarity with Iran's Jewish and Muslim cultural milieux and with the development of Persian miniature painting in general. Viewed in this larger context it is evident that Judaeo-Persian miniatures stand out as an important contribution to past Judaeo-Persian culture. Furthermore, when considered artistically within their socio-historical context these lovely and often quite sophisticated paintings show that they deserve a greater audience and recognition than they have received until now.

There exist twelve[1] accessible Judaeo-Persian manuscripts containing a total of 179 miniatures and many smaller page decorations. These manuscripts are scattered in various libraries, i.e., the Jewish Theological Seminary of America (JTS) in New York, the Klau Library of the Hebrew Union College-Jewish Institute of Religion (HUC) in Cincinnati, the Israel Museum (IM) and the Jewish National and University Library (JNUL) in Jerusalem, the British Library (BL) in London and the Stiftung Preussischer Kulturbesitz (SPK) in Berlin. They do not belong to the enticing genre of royal Persian manuscripts but rather to more primitive, provincial schools. They can be dated, on stylistic grounds, between the seventeenth and ninetenth centuries and are closely linked, chronologically as well as stylistically, to the development of the popular, provincial style of Iranian miniature painting in general.

The minatures illustrate Judaeo-Persian texts which were composed much earlier than the painting of the miniatures.

A beginning of the process of analysing Judaeo-Persian miniatures has already been made. Dr. Hans Striedl's excellent article "Die Miniaturen in einer Handschrift des jüdisch-persischen Ardašir-buches von Šāhīn (Stiftung Preussischer Kulturbesitz, Tübinger Depot, Ms. or. qu. 1680)"[2] not only gives a complete list of the illustrations contained in that manuscript but offers a thorough analysis of them establishing their date firmly as belonging to the middle of the seventeenth century. Professor Joseph Gutmann's article "Judeo-Persian Miniatures"[3] gives a more comprehensive review of the entire field of Judaeo-Persian miniature painting and points out areas which are still unexplored. It was this article that inspired me, an Iranologist, not an art historian by training, to undertake this study. I hope to facilitate the task of art historians in dealing with these miniatures by removing one major obstacle, their relationship to the Judaeo-Persian texts. This study consists largely of listing the illustrations and describing their contents. As much information as possible is offered about each manuscript. I have also expanded on the basic description of some pictures, pointing to already accessible classical Iranian miniatures where the same or related themes are depicted, and drawing attention to *leitmotifs* whose presence aids in the process of dating the illustrations. Each entry provides the page or folio number on which the miniature appears as well as its dimensions. Whenever possible, I tried to refer to recent editions of Persian texts and to their translations into Western languages of the passages in question.

The transliteration system employed throughout is that of the *International Journal of Middle East Studies.*

Introduction

The long history of Jews in Iran dates back at least as far as the period of the First Exile (586 B.C.E) when Nebuchadnezzar exiled thousands of Jews to Babylonia. The Jewish sojourn in Iran continued uninterrupted throughout the centuries until the present day. It was not always a peaceful sojourn; we know of anti-Jewish persecutions before Iran became a Muslim land and after, particularly between the seventeenth and nineteenth centuries. Nor did Iran's turbulent history filled with conquests by Arabs, Mongols, Turkic tribes and Afghans always provide a peaceful atmosphere conducive to cultural

achievements. Nevertheless, it is a fact that all levels of Iranian culture seem to have benefitted from the successive waves of outside influences and that, as a result of these influences, Iran possesses a unique culture endowed with magnificent literary and artistic achievements.

Our rather scanty records about Iranian Jewish communities during the Middle Ages indicate that although fairly numerous they were not especially prosperous at any given time. As elsewhere in the Muslim world, Jews held the status of "dhimmi" or protected religious minority. This status possessed by all "Peoples of the Book", including Christians and Zoroastrians, was applied to those people choosing to adhere to their ancestral faith at the cost of a type of "secondary" citizenship. Except for a brief period under the Mongols (1284-1291), Iranian Jews did not occupy important positions at court and were almost always at the bottom of the social scale, only a step above the Zoroastrians, devotees of Iran's pre-Islamic faith. Because they generally concern themselves exclusively with social groups and events involving the court, royal Iranian chronicles, our major sources of information about Iran in the Middle Ages, hardly ever mention Jews. When they do so,[4] it is to record large "voluntary" conversions to Islam. However, we know from Judaeo-Persian chronicles[5] that these conversions were hardly voluntary and were preceded by persecutions of varied intensity. From these chronicles we also glean that Iranian Jews never seem to have risen into the higher professions and were, by and large, metal craftsmen, petty merchants, weavers, dyers, tanners, etc. Always part of the lower class, Iranian Jews do not seem to have ever occupied the positions of money lenders, money changers, or prosperous merchants as they did in so many places and so frequently in Europe during the Middle Ages. In Iran, during the period under consideration, the first two of these positions was occupied by Bāniāns, a Hindu caste of businessmen, while the latter was almost exclusively monopolized by Armenians who were also in charge of the lucrative concession of silk trade.

Iranian Jews insisted on using the Hebrew alphabet even while writing in the Persian language as a symbol of preserving their religious and national heritage. This phenomenon occurred among several other Jewish communities in the Diaspora. Refusal to use the Arabic script, the script of the Koran as well as of the Persian language, meant a tacit affirmation of the ancestral faith in the face of forces of conversion and assimilation. This "self-imposed graphical barrier"[6] was nevertheless not monolithic. The large variety of Judaeo-Persian literature in existence – religious poetry, chronicles, tales, epics and even the transliteration of many Biblical books into Persian – attests to much strong

influence from the Iranian environment. Interestingly enough, Iranian Jews, in contrast to their Babylonian ancestors, did not produce major halakhic or legal literary tracts and seem to have been content to follow in the footsteps of the traditional teachers of the earlier Middle Ages.[7]

The influence of the Iranian environment so readily detectable in the literary works of Iranian Jews attests to the high degree of "acculturation" they achieved without relinquishing their identity. Many of the great epics of the Persian language found their way into Hebrew transliteration showing that the barrier of the alphabets was rather superficial in a land in which poetry was greatly loved and frequently recited. Iranian Jews shared fully the literary and artistic tastes of their Muslim compatriots. Under the creative Iranian influence they composed original literature of their own, some as audacious as setting the Pentateuch into Iranian epic verse. They also adorned their manuscripts with miniatures which, but for the Hebrew script, would be practically indistinguishable from contemporary Iranian miniatures.

It would seem that Iran had a flourishing pictorial tradition long before it was conquered by the Arabs. The art of book painting is said to have reached its peak in the hands of Mani (died 274), the founder of Manichaeism. The Arabs themselves lacked a pictorial tradition of their own.[8] The first Muslim (Arab) paintings reveal the marked influence of Byzantine iconography with which the conquerors came into contact very early. But the influence of pre-Islamic Iranian art, a tradition at least as ancient and as developed as that of the Roman-Byzantine world, is more difficult to discern in the earliest stages of Muslim iconography. It would seem however, that this tradition was by no means destroyed by the conquest but rather had gone "underground," particularly during the rule of the first two Muslim dynasties, the Umayyads (642-750) and the ʿAbbāsids (750-1258). This dormant period can be attributed to a large extent to the fact that early empire building favored architecture more than any of the other arts and to the often discussed unfavorable attitude of Islam towards painting in general. The Koran, in its great effort to wean pagan Arabs away from polytheism, enjoins against any kind of creativity that would compare or invite comparison with Divine creativity (Sura 5:110). There exists evidence to show that, despite the efforts of many theologians, this prohibition was not strictly followed and that early Muslims were not as iconoclastic as it had originally been thought. It is assumed with some justice that the prohibition against depicting the human figure encouraged the development of abstract designs and the glorification of colors characteristic of much Muslim art.

Despite the devastations of the conquests themselves, the Mongol destruction of the caliphate (1258) initiated a more religiously tolerant era, one in which the pictorial arts really began to flourish. The first known Iranian miniature paintings date back to this period and exhibit characteristics whose origins can be traced back to the Far East, the Byzantine Empire and pre-Islamic Iran. From this period on, miniature painting in Iran continued uninterrupted and gradually developed the subtlety of design and brilliant palette which places it among the most beautiful painting traditions in the world. The strides achieved during the Timurid period (1400-1450) climaxed under the first Safavid rulers of Iran (1502-1642) when the Tabriz school, essentially Turkman in style, gracefully combined with the painting traditions of the school of Herat. Determining why Persian miniature painting and the arts in general made such strides under the early Safavids, the rulers who enforced Shi'ism in Iran more by the sword than by any other means, remains a lively subject of debate among scholars of the period. While no satisfactory answers have as yet been offered, it has often been noted that under the Safavids there was a deliberate effort to encourage much that was "native" and "national", the multinational character of the kingdom's population notwithstanding. This effort was in conscious contrast to the more "cosmopolitan" ways of the Sunnīs, in particular those of the Ottoman Empire, the great rival of the Safavid kingdom.

Iranian miniature painting under the Safavids was patronized both by the rulers and by the highest aristocracy. Several shahs, such as Shah Tahmasp I (1524-1576), were accomplished painters and calligraphers. It was during his reign that the magnificent Houghton *Shāh Nāma*, begun during the reign of his father Shah Ismā'īl I, was finally completed.[9] From the busy royal ateliers the art of miniature painting spread to the smaller courts and workshops of the nobility and as far as the Moghul and Ottoman courts. By the middle of the seventeenth century the number of ateliers had spread even to the bazaars where a flourishing popular version of the high royal art began to develop in most of Iran's major centers. The history and development of this "popular" form of the high art and particularly its relationship to the beginning of the socio-political decline of Safavid Iran has not yet been fully written. Judaeo-Persian miniature painting belongs to this tradition and its study is important for the resconstruction of the larger field of popular Iranian miniature painting.

The illustrated Judaeo-Persian manuscripts included in this study can be divided by content into four types:

1. Hebrew transliterations of Persian classics, i.e., Jāmī's *Yūsuf and Zulaykhā* composed in 1483 (JTS 1496 and JTS 1534), Niẓāmī's *Haft Paykar* composed around 1198-1199 (BL Or. 4730) and his *Khosrow and Shīrīn* composed around 1175-1176 (JTS 1398).

2. Album leaves of miscellaneous poetry interspersed with portraits (BL Or. 10194).

3. Original works by the Jewish Persian poets Shāhīn and ʿImrānī written in Judaeo-Persian, i.e., Shāhīn's *Ardashīr Nāma* composed around 1330 (SPK or. qu. 1680 and JTS 40919), his *Mūsā Nāma* composed around 1327[10] (SPK or. oct. 2885, IM 180/54 and HUC 2102), and ʿImrānī's *Fatḥ Nāma* composed around 1474 (BL Or. 13704).

4. Works of dubious Judaeo-Persian origin and uncertain authorship such as "Shuʿlah's" *Yūsuf and Zulaykhā* (JNUL 38° 4418).

It is appropriate that the most interesting and original Judaeo-Persian miniatures occur in the third category, that of original Judaeo-Persian epics. This category contains the crowning literary efforts of Iranian Jews. The epics mentioned in this group are successful attempts at using Persian methods of versification and rhetoric in setting to verse some well-known Jewish themes. For example, the *Ardashīr Nāma* (The Book of Ardashīr [Ahashuerosh]) is the story of the Book of Esther. In Shāhīn's epic not only is Esther married to one of pre-Islamic Iran's great heroes whose many adventures are here recounted in great detail, but she is the mother of heroes herself. The epic ingeniously makes her the mother of Cyrus the Great, an even greater savior of the Jews than Ahashuerosh. Thus Shāhīn interweaves the Jewish tradition with the heroic tradition of Iranian epics and claims an audacious "historical" link with it. He does not hesitate to bring in Talmudic and Midrashic references when such material enhances the drama described in the story. For example, a Talmudic reference is beautifully woven into the story and masterfully illustrated (SPK or. qu. 1680, folio 82 recto). In the tractate Megillah (16a), it is told that in order to intensify Shah Ardashir/Ahashuerosh's anger towards Haman, God ordered "ten angels in the guise of Haman's sons to fell down trees in the royal park. When Ahashuerosh turned his eyes toward the interior of the park, he saw the ruthless destruction of which they were guilty...".[11] The story justifies the shah's anger not only against Haman but against his sons as well. The Judaeo-Persian miniature illustrating the story shows a large plane tree, the most frequently painted tree in Iranian miniature paintings in general, in the process of being uprooted by three angels. The angels' actions look more

like embracing or supporting the tree. The angels' grace is, perhaps, the artist's way of alluding to their supernatural origins.

The *Mūsā Nāma* (The Book of Moses) sets in verse much of Exodus, Leviticus, Numbers and Deuteronomy, emphasizing the action and omitting most of the legal parts; Shāhīn wrote a separate book on Genesis. Moses is described in the *Mūsā Nāma*, not only in the traditional Jewish heroic terms, but in the heroic language of Iranian epics as well. For example, in Iranian epic tradition all heroes are severely tried before they perform great saving deeds. In accordance with this tradition, Moses passes several trials in the desert by fighting various wild beasts, among them a lion, before he is found worthy of being addressed from the Burning Bush (IM 180/54, folio 31 recto; HUC ms. 2101, folio 22 recto). True to the Muslim iconographic requirement of not depicting the faces of holy men, Moses wears a veil across his face in many, but not all, of the miniatures; a clue, perhaps, to the identity of the artists of the miniatures. The traditional flaming halo of Muslim saints surrounds his head at all times.

Even more surprising than the interweaving of Jewish legendary material is the use in many of these epics of some Muslim legendary lore. Because these epics have not yet been studied from a purely literary point of view, it is not yet clear whether the Jewish Persian poets obtained such stories from written or oral sources. Nevertheless, their mere familiarity with such material bespeaks a high level of acculturation. For example, the death of Moses is described according to a legend, which is probably of more ancient origin, recorded by the great historian and theologian aṭ-Ṭabarī (died 923). Moses sees three angels, appearing as men, digging a grave. Replying to his inquiry, they tell him that the grave is meant for the "beloved of God" who is about Moses' size. They ask him to ascertain the correct size of the grave. Once inside, Moses is buried by the Angel of Death (IM 180/54, folio 247 verso).

The *Fatḥ Nāma* of 'Imrānī versifies the Books of Joshua, Ruth, Samuel I and, in the extant manuscripts, part of Samuel II. 'Imrānī envisioned himself as a follower of Shāhīn consciously aiming, like his predecessor, at "raising" the literary level of the Biblical tales to that of Iranian epics. It is this constant interweaving of Jewish and Persian literary elements and Jewish and Muslim legendary material that makes the literary quality of these epics worthy of much further study.

There is no discernible iconographic reason to suppose that the painters were Jewish, interpreting their subject in some peculiarly Judaeo-Persian style. We have no tangible evidence that Persian Jews ever practiced this form

of art although, judging by examples from other lands, this possibility cannot be ruled out. It is well known that miniature painting reached a high degree of perfection among the Jews of Spain, particularly in the thirteenth and four-teenth centuries, and among the Jews of Italy during the Renaissance, espe-cially during the fifteenth century.[12] In both these cases, as with Judaeo-Persian miniatures, the artistic influence of the environment was overwhelm-ing. Unfortunately, our Judaeo-Persian miniatures are unsigned and it is doubtful that we can ever become certain of the identities of the painters. It is possible that Dr. Striedl's hypothesis based on his analysis of the *Ardashīr Nāma* (SPK or. qu. 1680),[13] which states that it is the product of a traditional Muslim workshop, may well apply to all the manuscripts consulted in this study. Nevertheless, we cannot rule out the possibility that Jewish hands could also have been at work in such workshops.

There exist quite a number of discrepancies between the illustrations and the texts they depict which can, perhaps, best be explained if we consider the miniatures to have been a "joint venture", the Jewish calligrapher and/or patron conveying the meaning of the texts to a Muslim painter. For example, in the *Mūsā Nāma* (SPK 2885, folio 5 verso) the text in the picture indicates that Moses' arms were made to rest on piles of rocks during a major battle of the Jews against the Amalekites (Exodus 17:8-13). However, in the Bible Moses sits on a rock when he grows tired during the course of the battle (Exodus 17:12) and his arms are upheld only by Aaron and Hur. The illus-tration indicates some confusion on the part of the painter who, if he were a Muslim told about the Biblical account and Shāhīn's text, and being himself unable to check the original Hebrew or Judaeo-Persian texts, could have mixed up some of the details. In a similar case, according to the text in the *Ardashīr Nāma* (SPK or. qu. 1680, folio 5 recto), Shah Ardashīr was supposed to be hunting on foot, yet the illustration shows him mounted. Again in the same manuscript, according to the text on folio 103 recto, Prince Shīrū, one of Ardashīr's sons, is supposed to be hiding in a tree because his quiver is empty. He is, however, depicted as actively defending himself from wolves when a dragon appears. He is also supposed to be alone, not accompanied by his horse and servant as he is shown in the miniature.

The above mentioned discrepancies support the hypothesis that many of these Judaeo-Persian miniatures may be the products of traditional Muslim work-shops which may or may not have counted Jews among their masters and appren-tices. In any case, we must suppose that at the very least a Jewish intermediary was involved who would have given a description of the desired miniature.

The miniatures in each manuscript are painted by the same hand(s) throughout. There are many tell-tale signs of this. For example, in the *Ardashīr Nāma* (SPK or. qu. 1680) numerous miniatures have very similar pink backdrops with gray bird and animal designs. The same or very similar rug designs and some of the same faces, such as that of Shah Ardashīr's attendant, are encountered in numerous miniatures. The other copy of the *Ardashīr Nāma* (JTS 40919) has a grill design in the backdrop of almost every miniature and similar tufts of vegetation appear in several scenes. Here too, a certain poverty of imagination is apparent in the frequent use of pink backdrops with bird and animal designs and in the repeated use of the same rug design.

This repetition of design and composition within each manuscript precludes the possibility of different ateliers and even different individual painters working on a manuscript at different times, places and in different styles. This, of course, distinguishes them sharply from the products of the royal ateliers which, very often, were the result of cooperation between several individuals over a fairly long period of time. In fact, the workmanship involved in the Judaeo-Persian miniatures is very similar, both in style and the materials used, to that of popular Iranian miniatures in general. These are generally far from the style and materials used in royal ateliers in that they were of much lower quality. Nevertheless, the basic techniques were the same. The miniatures were originally drawn with reed pens or brushes after which most were colored in opaque watercolor or gouache. Pigments varied and their manufacture was an important part of the artists' training as was the manufacturing of fine brushes out of squirrel or kitten hairs set in bird quills and made to fit the grip of the specific artist. Royal manuscripts generally employed pigments of natural ingredients such as crushed insects, silver, gold and crushed lapis lazuli, that most beautiful of Persian blues. However, we see few traces of such materials in Judaeo-Persian manuscripts.

There are many calligraphic differences between the manuscripts included in this study and a thorough study of them placed in the context of the historical development of the Hebrew script is much to be desired. Two manuscripts, IM 180/54 and SPK or. qu. 2885, may well have been copied by the same individual. On the other hand, there seem to be no major differences in the system of transliteration employed for transliterating Persian texts into the Hebrew alphabet. One such difference, however, jumps to the eye at once. The Hebrew Union College manuscript (HUC ms. 2102) of Shāhīn's *Mūsā Nāma* consistently spells the name of Joshua as יושע which is the transliteration of the Arabic (and Persian) يـوشــع. In all the other manuscripts of the

epic as well as in 'Imrānī's *Fatḥ Nāma* the name is spelled in the correct Hebrew form, יהושע . This is not entirely surprising since the Hebrew Union College manuscript, dating from around 1877, exhibits several other features that place it in a more popular "colloquial" setting. For example, almost every one of its chapter headings is concluded by the folk expression "va salām", a feature not found in any of the other copies. It also lacks all indications of *parashah* (weekly synagogue readings from the Pentateuch) headings, in contrast with the IM manuscript 180/54 of the *Mūsā Nāma* which gives numerous *parashah* headings thereby indicating great awareness of the relationship between the events being versified and their original form in the Pentateuch. This feature might well indicate that this manuscript emerged from a more learned Jewish community than the later Hebrew Union College copy.

Judaeo-Persian miniatures, like their contemporary Iranian miniatures, demonstrate the decline of this form of art which set in by the end of the seventeenth century. This decline continued throughout the eighteenth and nineteenth centuries and resulted from the absence of great painters and patrons. Many artists fled to India and the Ottoman Empire during the years of increasing Shīʿī fanaticism and political turmoil that accompanied the downfall of the Safavid dynasty. The techniques of the royal ateliers became permanently lost although their popular versions continued to survive in the bazaars of Iran.

It is to be hoped that this preliminary study will facilitate inquiry into the all important questions of when, where, by whom and for whom these miniatures were made. Since an examination of Judaeo-Persian miniature paintings, like that of most Iranian miniature paintings in general, reveals no painters' signatures, we have as yet no firm basis for an opinion regarding the nature, Jewish or non-Jewish, of the workshops from which the paintings emerged.

Judaeo-Persian miniatures are of interest because they help trace the development of the popular and provincial artistic tradition in Iran. They echo closely all the developments of the Persian popular form though it remains to be determined which specific branches they resemble most.[14] Above all, they are a record and testament of the cultural tastes and achievements of Iranian Jews during the latter part of the Middle Ages.

Notes to Introduction

1. Unfortunately, it is impossible to ascertain whether more such manuscripts might still be found in Iran.

2. Striedl, "Die Miniaturen." *Forschungsberichte* 10 (1966): 119-133.

3. Gutmann, "Judeo-Persian Miniatures." *Studies* 8 (1968): 54-76 and Gutmann, *No Graven Images*, 1971, 466-488.

4. See Wahīd, *'Abbāsnāma*, 1951, 218-219, for a description of the conversions of 1656-1661.

5. There are two important Judaeo-Persian chronicles that deal with the experiences of Iranian Jews in the seventeenth and eighteenth centuries. The first, the *Kitāb-i Anusī* of Bābāī ibn Luṭf, is the subject of my *Iranian Jewry's Hour of Peril and Heroism*, forthcoming, and deals with the periodic persecution of Iranian Jews between 1617 and 1662. The second, the *Kitāb-i Sar Guzasht-i Kāshān dar bāb-i 'Ibrī va Goyimi-yi Sānī*, is by Bābāī ibn Farhād, the grandson of Bābāī ibn Luṭf, and deals primarily with the conversion of the Jews of Kāshān around 1730. I am currently editing and translating this work.

6. Fischel, "The Literary Heritage of Persian Speaking Jews." *JWB Annual* 27 (1970): 5.

7. For a fuller historical background on Jews in Iran, see Baron, *A Social and Religious History*, vol. 18, chap. 79.

8. The following summary is primarily based on Arnold, *Painting in Islam*, 1965; Ettinghausen, *Arab Painting*, 1977; and Gray, *Persian Painting*, 1977.

9. See Dickson and Welch, *The Houghton Shahnamah*, 1981.

10. The dating of Shāhīn's work is based on the pioneering and still relevant study by Bacher, *Zwei Jüdisch-Persische Dichter*, 1907-8, 8-9. Netzer, *Muntakhab*, 1973, 37-39, agrees with the date of composition of the *Ardashīr Nāma*, but gives 1317 as the date of composition for the *Mūsā Nāma* without explaining his reasons.

11. See Ginzberg, *Legends*, 1913, 4: 442 and 6: 478 note 181.

12. See Gutmann, *Hebrew Manuscript Painting*, 1978 and Narkiss, *Hebrew Illuminated Manuscripts*, 1974.

13. Striedl, "Die Miniaturen." *Forschungsberichte* 10 (1966): 132-133.

14. For the various provincial and popular styles in Persian miniature painting, see Robinson, *Persian Paintings*, 1976.

Catalogue

I. Jāmī's *Yūsuf and Zulaykhā*

(JTS 1496)

This is a Judaeo-Persian fragment of the famous Persian epic containing approximately five chapters (12 folios); beginning and end pages are out of order. The paper is fairly dark brown and restoration prevents the detection of watermarks. The format is small, the pages measuring 17.2 x 12.6 cm. The binding has been restored. This fragment contains only one miniature. The script is in the same hand throughout. The date of the manuscript is uncertain, perhaps the middle of the seventeenth century.

This manuscript, acquired by Elkan N. Adler during his trip to Tehran in the autumn of 1896, is briefly noted in Adler, *The Persian Jews*, 1898, p. 21, as "T77". For the Persian text see Jāmī, *Yūsuf o Zulaykhā*, 1916. For a translation of the text see Djami, *Youssouf et Zouleikha*, 1927.

1. **Folio 8 recto, 12.7 x 11 cm.**

The miniature is divided into three panels:

> a. Top right corner: On her roof top, accompanied by her faithful nurse, Zulaykhā is in nightly contemplation of Yūsuf in prison.
> b. Left, largest panel: Yūsuf is meditating in his prison cell. His head is surrounded by a glowing halo characteristic of holiness in Muslim iconography.
> c. Bottom right corner: Probably Jacob mourning his son Yūsuf.

Jāmī, *Yūsuf o Zulaykhā*, 1916, pp. 244-251; Djami, *Youssouf et Zouleikha*, 1927, pp. 167-170.

II. "Shu'lah's" (?) *Yūsuf and Zulaykhā*

(JNUL 38° 4418)

This is an incomplete copy of the *Yūsuf and Zulaykhā* epic composed not by Jāmī, but, according to Professor Amnon Netzer of the Hebrew University of Jerusalem, by someone bearing the pen-name "Shu'lah" ('Flame'). As he informs me by correspondence, there are several Iranian authors with this pen name, i.e. Sayyīd Muḥammad Tabīb Isfahānī (died 1225 A.H./1810), but this work cannot be attributed to him. Professor Netzer believes, on stylistic grounds, that it was composed by an Iranian Jew hailing from western Iran. But E. Wust, in a recent study, "Yahudei

Iran va Sifrut Farsit," in *Kiryat Sefer* 58 (1983): 613-616, described this manuscript in detail and arrived at the conclusion that it is the work of a Muslim author written in 1175 A.H./1761.

The manuscript, which lacks the ending, contains 133 pages and has two miniatures, one on the inside of one of the covers and the other on the first page. The introduction and beginning of the text were completed by the scribe Yehezkel Qatan in 1897. The manuscript is listed in Adler, *Catalogue of Hebrew Manuscripts in the Collection of E.N. Adler*, 1921, p. 63, no. 44. The names of two owners are indicated: Hajjī Dāud ben Hajjī Mashiah of Hamadan (1922) who had two sons born in 1917 and 1919 and Moshe Hayyim ben… 1928. The manuscript is noted but not properly identified or described in *Manuscripts and Rare Books*, April-May 1970, p. xviii, no. 22.

Dr. M. Nadav, Head of the Department of Manuscripts and Archives of the Jewish National and University Library, informs me that the library's experts believe, based on the lack of relationship between the pictures and the text of the epic, that the miniatures are of purely Iranian, non-Jewish provenance and that the picture on the inside cover was probably inserted as a fly leaf just before the sale of the manuscript. The miniatures probably date from no earlier than the end of the eighteenth century and are most likely from the first half of the nineteenth century.

1. Inside cover, 20.1 x 14.1 cm.

The subject of this picture is difficult to determine because: the authorship of the epic is uncertain, the miniature is out of order and there are no "clue" verses in the picture itself. Given these hindrances it is fairly safe to assume that in this miniature Yūsuf, who is standing in the door of his tent, has a vision of his father Jacob just before his (Yūsuf's) death. Zulaykhā, her faithful nurse (left top corner), and perhaps some of Yūsuf's servants are in the background, but are not necessarily sharing Yūsuf's vision.

If the identification is correct it, in turn, provides support for not attributing the epic to Jāmī. In Jāmī's work Yūsuf, while entirely alone, has a vision of both his father and mother. Similarly, the males near Zulaykhā could be considered Yūsuf's brothers, but again they play a very limited role in Jāmī's epic and are certainly not near him during this episode.

2. Page 1, 5.9 x 8.5 cm.

A seated, bearded prince talks to four men standing before him. The setting is the interior of a palace; a garden is visible outside. The subject of the miniature is entirely a matter of conjecture. It could be the author telling his story to an audience; or, more likely, these are subjects standing before their prince, among them the author. The work may be dedicated to the prince.

III. Jāmī's *Yūsuf and Zulaykhā*

(JTS 1534)

This is a complete Judaeo-Persian copy of the epic containing 122 pages of text, two ornamented pages *(sar-i lawḥ)*, and twenty-six miniatures, some of which are divided into two panels. It has a colophon indicating that the copying, all in one hand, was completed on the third day of the week [Tuesday], the twelfth day of 'Menahem' [Av] of the Jewish year 5612. The copyist carefully correlates this Jewish date with the Muslim date, Dhu'l Qa'dah, 1269 A.H., which corresponds to Tuesday August 16, 1853 C.E. He gives his name as Eliyahu ben Nissan ben Eliyah known as "Gurgī" ("the Georgian") living in the town of Mashhad during the reign of the Qājār Shah Nāṣir ud-Dīn (reigned 1848-1896). His avowed purpose for copying this manuscript was to admonish his contemporaries and encourage them to improve their behavior.

The manuscript retains the original binding, black with thin yellow margins. Both front and back inside flaps have large floral designs signed illegibly. There are a number of pages at the beginning and end of the manuscript lined for verse but covered with various doodles, some even in Russian(!). The paper is light brown and no watermarks are discernible. The pages measure 26.2 x 16.1 cm. At the side of almost every miniature there is a blue or gold stamp on which the subject of the illustration is indicated, though many stamps lack such a description. This manuscript was donated to the Library of the Jewish Theological Seminary of America by Mr. Harry G. Friedman on September 2, 1955. For the Persian text see Jāmī, *Yūsuf o Zulaykhā*, 1916. For a translation of the text see Djami, *Youssouf et Zouleikha*, 1927.

1. Page 1, 5.7 x 10.5 cm.

A *sar-i lawḥ* (ornamental design at the top of a page) is shown on the top third of the page containing an illuminated arch in lovely colors, predominantly blue.

2. Page 2, 9.8 x 11 cm.

Shown is a similar *sar-i lawḥ* on the top third of the page.

3. Page 6, 11 x 10.5 cm.

This shows the *miʿrāj* or ascension of the Prophet Muḥammad to the Divine Throne. The "hybrid" mount is Burāq while the angels above are probably Gabriel and Michael. Two other angels, also part of the entourage, are holding some small fans or brooms. Burāq looks even more phantasmagoric than usual, adorned with a Qājār style head and hat, a bird-shaped saddle and an inordinately large tail. The Prophet himself is absent from the picture suggesting, perhaps, that he is already in the Divine Presence where none could accompany him. This is a very famous and popular topic of Muslim iconography. Its best illustration is, without a doubt, the miniature attributed to Sulṭān Muḥammad in the *Khamsa* of Niẓāmī made between 1539 and 1543 at the court of the Safavid Shah Ṭaḥmāsp (see Welch, *Royal Persian Manuscripts*, 1976, pp. 96-97). For the same theme depicted in a style almost identical with this Judaeo-Persian miniature see Plate LVIb (18th century) in Arnold, *Painting in Islam*, 1965.

Jāmī, *Yūsuf o Zulaykhā*, 1916, pp. 14-19; Djami, *Youssouf et Zouleikha*, 1927, pp. 10-13.

4. Page 10, 11.7 x 10.5 cm.

The poet Jāmī (right) is standing before his celebrated patron the Timurid Sulṭān Ḥusayn b. Manṣūr b. Bāyqarā of Herat (reigned 1468-1506) whom he addresses as the "Yūsuf of this Egypt". Behind the throne is probably the Sultan's eldest son, Badīʿ az-Zamān. The stamp at the side claims that the picture contains the likeness of "Muẓaffar Shah," by whom is probably meant Muẓaffar ud-Dīn Shah, who reigned 1896-1907. This would place the manuscript in the next reign, contrary to the claims of the colophon, unless the likeness is meant to be identified with the figure of the son, Badīʿ az-Zamān.

Jāmī, *Yūsuf o Zulaykhā*, 1916, pp.24-27; Djami, *Youssouf et Zouleikha*, 1927, pp. 18-20.

5. Page 15, 13.5 x 11 cm.

Adam, the oldest bearded figure seated (left), surveys all the virtuous people of creation (right) but finds Yūsuf (far left) surpassing them all in beauty and virtue. Adam shows him special love by bestowing upon him two thirds of the beauty destined for mankind.

Jāmī, *Yūsuf o Zulaykhā*, 1916, pp. 37-39; Djami, *Youssouf et Zouleika*, 1927, pp. 27-29.

6. Page 21, 11.2 x 10.5 cm.

The seven-year-old sleeping Zulaykhā for the first time beholds the vision of Yūsuf in a dream. It marks the beginning of her life-long passion.

Jāmī, *Yūsuf o Zulaykhā*, 1916, pp. 51-55; Djami, *Youssouf et Zouleikha*, 1927, pp. 37-40.

7. Page 27, 9.2 x 10.6 cm.

Distraught by her second vision of Yūsuf, Zulaykhā tries to run away from home to find him. Her father (left) decides to bind her with a golden chain lest she disgrace him. The physical bondage is ironic since Zulaykhā is already a prisoner of her love. For the same theme depicted in an earlier style (circa 1560) see Robinson, *Persian Paintings in the India Office Library*, 1976, p. 102, no. 297.

Jāmī, *Yūsuf o Zulaykhā*, 1916, pp. 65-71; Djami, *Youssouf et Zouleikha*, 1927, pp. 46-49.

8. Page 38, 10.5 x 10.6 cm.

Zulaykhā is brought to Egypt on a camel as the betrothed of ʿAzīz (Potiphar). She is greeted by men strewing precious jewels in her path. The largest male figure in the center is ʿAzīz himself, while the crouching figure is a servant whose back will be Zulaykhā's stepping stool upon alighting from the camel. For the same theme depicted in an earlier style (circa 1556-1565) see Welch, *Royal Persian Manuscripts*, 1976, p. 25.

Jāmī, *Yūsuf o Zulaykhā*, 1916, pp. 96-100; Djami, *Youssouf et Zouleikha*, 1927, pp. 62-63.

9. Page 45, 9.5 x 10.6 cm.

On the way to being thrown into the pit, Yūsuf, in chains, is maltreated by his brothers.

Jāmī, *Yūsuf o Zulaykhā*, 1916, pp. 117-123; Djami, *Youssouf et Zouleikha*, 1927, pp. 80-84.

10. Page 87, 10 x 11 cm.

Yūsuf is pulled out of the pit by the Midianite merchants (left) while his brothers (right) watch apprehensively. This miniature is put here in the proper order of the story, but it is misplaced in the manuscript. For the same theme depicted in an earlier style (circa 1556-1565) see Plate 40 in Welch, *Royal Persian Manuscripts*, 1976, p. 25. The theme is also reminiscent of the famous rescue of Bīzhan from the pit by Rustam in Firdawsī's *Shāh Nāma*. See for example, Plate LXXV in Blochet, *MusulmanPainting XIIth – XVIIth Century*, 1975.

Jāmī, *Yūsuf o Zulaykhā*, 1916, pp. 123-126; Djami, *Youssouf et Zouleikha*, 1927, pp. 84-86.

11. Page 48, 11 x 10.5 cm.

Upon his arrival in Egypt Yūsuf, at the right of the scale, is being purchased from the Midianite merchants by Zulaykhā, who offers twice the sum of any other bidder; she sold her pearls to raise the necessary sum. The woman on the left is probably Zulaykhā's actual representative at the transaction. Six bags of money are already on the ground. For the same theme depicted in earlier styles see Gray, *Persian Painting*, 1977, p. 144 (circa 1570) and Robinson, *Persian Paintings*, 1976, p. 69, no. 209 (Qazwīn, late 16th century), p. 140, no. 468 (Shīrāz, circa 1590-1600).

Jāmī, *Yūsuf o Zulaykhā*, 1916, pp. 135-140; Djami, *Youssouf et Zouleikha*, 1927, pp. 93-95.

12. Page 50, in two panels 7.2 x 5 cm. each

Having heard of his beauty and virtues, Bāzigha of the tribe of 'Ad seeks out Yūsuf. However when she meets him, he is able to change her earthly desires into love for the Creator of Beauty.

Jāmī, *Yūsuf o Zulaykhā*, 1916, pp. 140-147; Djami, *Youssouf et Zouleikha*, 1927, pp. 96-100.

13. Page 54, in two panels 7.3 x 4.8 cm. each

Yūsuf tells Zulaykhā about his family problems. Zulaykhā recalls sensing his danger in the pit at the very time he was there.

Jāmī, *Yūsuf o Zulaykhā*, 1916, pp. 151-154; Djami, *Youssouf et Zouleikha*, 1927, pp. 103-105.

14. Page 55, in two panels 4.7 x 6.6 cm. (left); 5.6 x 6.5 cm. (right)

The telepathic closeness of the lovers is further exemplified by the famous case of Layla and Majnūn, the greatest unfulfilled lovers of Arabic literature. Layla had her arm bled (right) at the same time that Majnūn's arm was bleeding in the desert (left).

Jāmī, *Yūsuf o Zulaykhā*, 1916, pp. 151-154; Djami, *Youssouf et Zouleikha*, 1927, p. 104.

15. Page 56, 10.6 x 8 cm.

While in Zulaykhā's household, Yūsuf wishes to become a shepherd since he knows that among his ancestors only shepherds became prophets and leaders. Zulaykhā (right corner) fulfills his wish by giving him a choice flock and some shepherd companions. For the same theme depicted in an earlier style (circa 1556-1565) see Robinson, *Persian Drawings*, 1965, p. 75, Plate 45.

Jāmī, *Yūsuf o Zulaykhā*, 1916, pp. 154-156; Djami, *Youssouf et Zouleikha*, 1927, pp. 105-107.

16. Page 62, 10.7 x 9 cm.

Yūsuf awaits Zulaykhā in one of her fairest gardens where she hopes to seduce him.

Jāmī, *Yūsuf o Zulaykhā*, 1916, pp. 171-175; Djami, *Youssouf et Zouleikha*, 1927, pp. 117-120.

17. Page 69, 11 x 8 cm.

Zulaykhā's nurse, determined to help her mistress, orders a wondrous palace built for Zulaykhā. It is filled with images of Yūsuf and Zulaykhā in various love-making poses. Here is a rather tame sample of the subject showing them holding hands. For the same theme depicted in earlier styles see Stchoukine, *Les Peintures*, 1959, Plate LXXXIV (circa 1580) and Arnold, *Painting in Islam*, 1965, Plate XXXIIa (circa mid-16th century).

Jāmī, *Yūsuf o Zulaykhā*, 1916, pp. 187-193; Djami, *Youssouf et Zouleikha*, 1927, pp. 126-128.

18. Page 74, 7.7 x 6.2 cm.

Yūsuf is fleeing from Zulaykhā and leaving the grounds of the seventh pavilion of the palace. The enticing pictures it contains and Zulaykhā's charms almost achieve their purpose, but at the last moment Yūsuf is saved by the sight of an idol and flees with his chastity and faith intact. For the same theme depicted in an earlier style (1489) by the famous Bihzād see Binyon, *Persian Miniature Painting*, [1971], Plate LXXI-B 83 (e).

Jāmī, *Yūsuf o Zulaykhā*, 1916, pp. 193-204; Djami, *Youssouf et Zouleikha*, 1927, pp. 128-132.

19. Page 80, 10.7 x 7.2 cm.

Zulaykhā invites her friends who mock her love for Yūsuf to a sumptuous feast and has Yūsuf wait on them. Shocked by his beauty, they wound themselves while paring oranges and many faint. Zulaykhā herself is holding an orange and a sharp cutting instrument while Yūsuf waits on her. This theme is often depicted in Iranian miniatures. One of the best earlier examples (circa 1522) is in Binyon, *Persian Miniature Painting*, [1971], Plate LXXXVI 129 (c).

Jāmī, *Yūsuf o Zulaykhā*, 1916, pp. 222-227; Djami, *Youssouf et Zouleikha*, 1927, pp. 146-152.

20. Page 82, in two panels 5.5 x 7 cm. each

Convinced of the validity of Zulaykhā's passion her friends try to persuade Yūsuf to yield to her.

Jāmī, *Yūsuf o Zulaykhā*, 1916, pp. 222-227; Djami, *Youssouf et Zouleikha*, 1927, pp. 152-155.

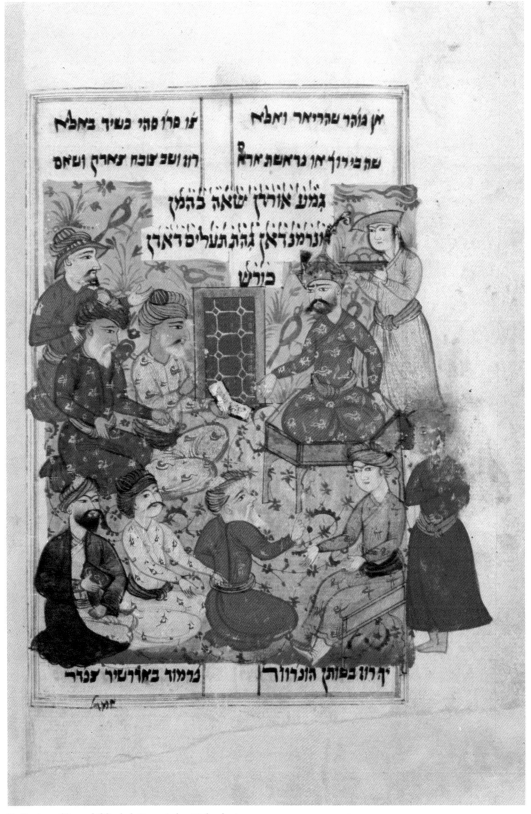

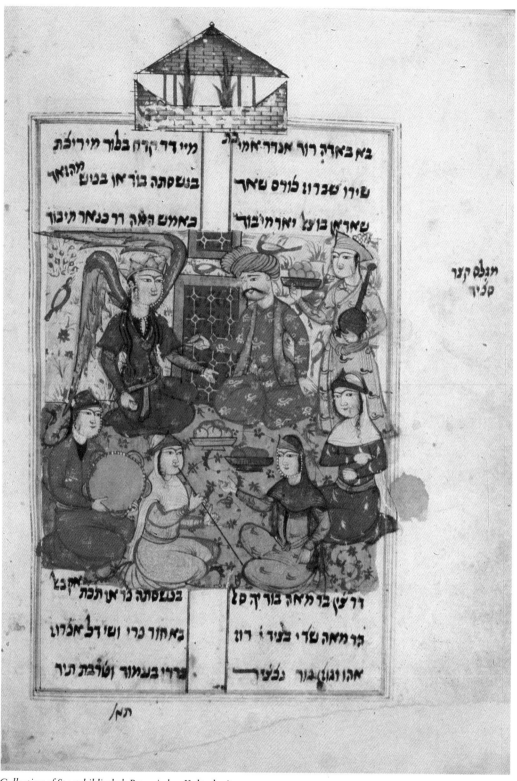

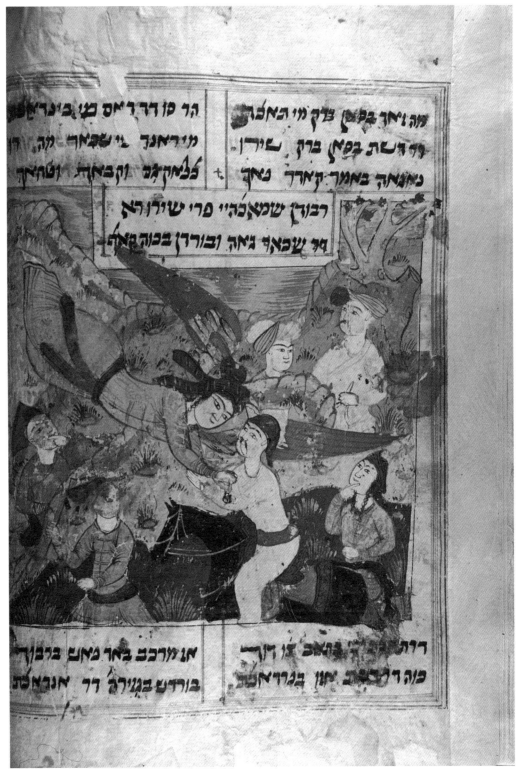

מה נ׳אר בקٰ׳ בדק מי תٰאבٰ׳ הר סٰו דר ר׳ٰס מٰ׳ ב׳גר׳שٰ
מٰ׳ דٰשٰת בٰקٰٰ׳ برق ש׳רٰ׳ מٰ׳ר׳אٰ׳د בٰ׳ שٰ׳אٰر מٰ׳ רׁٰ
כٰ׳אٰנٰאٰ׳ באٰמٰר קٰ׳אٰ׳ר כٰ׳אٰ׳ وق בٰ׳אٰ׳ٰ ٰטٰ׳אٰ׳ٰ

רٰבٰ׳רٰן שٰמٰ׳אٰכٰ׳�ٰ׳ٰٰ פٰ׳ٰ שٰ׳ٰ׳ٰ וٰ׳א
פٰ׳ שٰ׳כٰ׳אٰ׳ٰ גٰ׳אٰ׳׳, וٰبٰ׳ٰרٰדٰן בٰ׳כٰ׳וٰ׳ٰٰ בٰ׳אٰ׳ٰ

דٰרٰ׳תٰ׳׳٥ٰ בٰ׳וٰ׳אٰ׳ٰٰٰ גٰ׳ו חٰ׳ٰרٰ׳ אٰ׳ٰ מٰ׳רٰכٰ׳ב בٰ׳אٰ׳ר מٰ׳אٰ׳ שٰ׳ בٰ׳ רٰבٰ׳וٰ׳ٰ
כٰ׳וٰ׳ٰ דٰ׳ ر٥בٰ׳אٰ׳ٰٰٰٰ ׳מٰ׳ٰ׳ן בٰ׳ גٰ׳ר׳אٰ׳בٰ׳ٰ בٰ׳ٰ׳ר׳׳ٰش בٰ׳גٰ׳זٰ׳ٰر בٰ דٰ׳ר אٰ׳נٰ׳בٰ׳אٰ׳שٰ׳ٰٰٰ

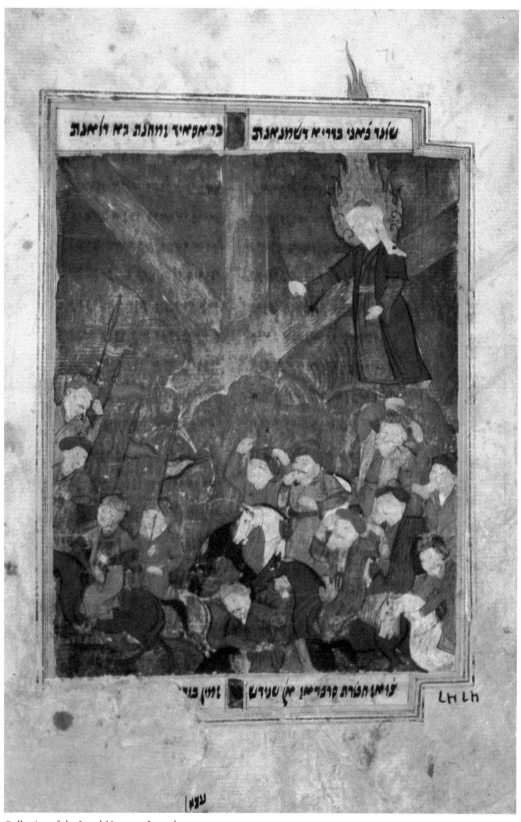

Collection of the Israel Museum, Jerusalem

21. Page 85, 8.6 x 10.7 cm.

Yūsuf is led to prison at the instigation of Zulaykhā's friends. He is mounted on a donkey and is followed by guards. A herald precedes him proclaiming:

> …All impudent, rebellious slaves who adopt disrespectful manners, daring to step on their master's carpet deserve, like all indecent men, to be thus carried in abjection into prison … (translation by V.B. Moreen)

For the same theme depicted in an earlier style (circa 1556-1565) see Welch, *Royal Persian Manuscripts*, 1976, p. 25 N.

Jāmī, *Yūsuf o Zulaykhā*, 1916, pp. 227-232; Djami, *Youssouf et Zouleikha*, 1927, pp. 155-159.

22. Page 93, in two panels 5 x 9.3 cm. each

Yūsuf in prison (left) interprets the dreams of other prisoners. Despite the chains he is wearing in the miniature, he is well treated thanks to Zulaykhā's arrangements.

Jāmī, *Yūsuf o Zulaykhā*, 1916, pp. 251-258; Djami, *Youssouf et Zouleikha*, 1927, pp. 171-173.

23. Page 97, in two panels 5 x 7.6 cm. each

Yūsuf is received in great honor by Pharaoh who appoints him governor of Egypt upon the death of 'Azīz.

Jāmī, *Yūsuf o Zulaykhā*, 1916, pp. 258-262; Djami, *Youssouf et Zouleikha*, 1927, pp. 178-180.

24. Page 100, in two panels 4.8 x 7.2 cm. each

In utter despair at Yūsuf's neglect, Zulaykhā builds herself a hut, here of rather palatial dimensions, from which she can observe the comings and goings of Yūsuf.

Jāmī, *Yūsuf o Zulaykhā*, 1916, pp. 269-273; Djami, *Youssouf et Zouleikha*, 1927, pp. 186-188.

25. Page 105, in two panels 4.8 x 8 cm. each

The angel Gabriel appears to Yūsuf to grant him divine permission to marry the rejuvenated and religiously transformed Zulaykhā. Yūsuf's baldness might be an indication that he is no longer in the prime of youth. For the same theme depicted in an earlier style (1540) see Robinson, *Persian Drawings*, 1965, p. 69, Plate 38.

Jāmī, *Yūsuf o Zulaykhā*, 1916, pp. 273-278; Djami, *Youssouf et Zouleikha*, 1927, pp. 192-195.

26. Page 106, 7 x 10.7 cm.

This depicts the celebration of the wedding of Yūsuf and Zulaykhā.

Jāmī, *Yūsuf o Zulaykhā*, 1916, pp. 278-283; Djami, *Youssouf et Zouleikha*, 1927, pp. 195-198.

27. Page 111, 8.2 x 10.7 cm.

The dead Yūsuf is mourned by Zulaykhā and a male attendant.

Jāmī, *Yūsuf o Zulaykhā*, 1916, pp. 293-297; Djami, *Youssouf et Zouleikha*, 1927, pp. 204-208.

28. Page 113, 10.5 x 10.7 cm.

Grieving violently over the death of Yūsuf, Zulaykhā blinds herself and expires upon his tomb. A very similar interpretation and execution of this theme is found in Diyakonova, *Sredneazyatskye Miniaturi*, 1964, no. 55, made in Darvāz in 1797-1798.

Jāmī, *Yūsuf o Zulaykhā*, 1916, pp. 293-297; Djami, *Youssouf et Zouleikha*, 1927, pp. 204-208.

IV. Niẓāmī's *Haft Paykar*

(BL Or. 4730)

This manuscript is an incomplete copy of the Persian epic containing 141 folios and thirteen miniatures which cannot, on stylistic grounds, date later than the beginning of the 18th century. There are two full page miniatures (49 verso and 128 recto) and two themes are repeated (128 recto and 129 recto). The text and the pictures are on polished white paper bound by a British Library binding. The manuscript was bought from S.J.A. Churchill Esq. on February 2, 1894. The poor design of the miniatures is generally mitigated by their pleasing colors. The calligraphy is in the same hand throughout. The pages measure approximately 22 x 14 cm. For the Persian text see Niẓāmī, *Kulliyāt*, (1972). For a translation of the text see Nezami, *La Sette Principesse*, 1967.

1. Folio 16 verso, 9 x 11.5 cm.

With one arrow Bahrām Gūr pierces a lion and its prey, a wild ass. A charging horseman is visible, but most of the picture is badly damaged. For the same theme depicted in an earlier style (circa 1540) see Welch, *Wonders of the Age*, 1979, p. 172, no. 64.

Niẓāmī, *Kulliyāt*, (1972), p. 639; Nezami, *La Sette Principesse*, 1967, pp. 54-55.

2. Folio 39 verso, 14.5 x 10 cm.

In the presence of Fitnah, his favorite singing girl, Bahrām Gūr pierces the head and hoof of a gazelle with one arrow.

This is a very famous theme in Iranian miniature paintings. For the same theme depicted in earlier styles see Welch, *Wonders of the Age*, 1979, p. 175, no. 65 (circa 1540); Akimushkina and Ivanova, *Persidskye Miniaturi*, 1968, no. 4 (Herat, circa 1431); and Robinson, *Persian Paintings*, 1976, p. 36, no. 108.(Turkman style, circa 1505).

Niẓāmī, *Kulliyāt*, (1972), p. 667; Nezami, *La Sette Principesse*, 1967, pp. 78-79.

3. Folio 35 verso, 9.5 x 12 cm.
Fitnah climbs a ladder with a calf on her back to prove to Bahrām Gūr (crowned figure at the top of the ladder) that anything is possible with sufficient practice. This is her answer to the shah's feat in miniature no. 2 above.

This is also a very famous theme of Iranian miniature painting. For the same theme depicted in earlier styles see Akimushkina and Ivanova, *Persidskye Miniaturi*, 1968, no. 29 (Shīrāz, 1508); Robinson, *Persian Paintings*, 1976, p. 36, no. 109 (Turkman style, circa 1505); and Stchoukine, *Les Peintures*, 1977, Plate X (circa 1442) and Plate LXXVIIIa (circa 1560).

Niẓāmī, *Kulliyāt*, (1972), p. 672; Nezami, *La Sette Principesse*, 1967, pp. 81-82.

4. Folio 49 verso, 12 x 10 cm.
This full page miniature is preceded by a blank page lined for, but without, text. It represents a feast with Bahrām Gūr offering a cup to a lady. The text that precedes and follows the miniature indicates that the theme is the same as in miniature no. 5 below.

Niẓāmī, *Kulliyāt*, (1972), p. 684; Nezami, *La Sette Principesse*, 1967, pp. 96-100.

5. Folio 51 verso, 14.5 x 10 cm.
In the midst of a winter feast Bahrām Gūr decides to have seven pavilions built for the seven princesses.

Niẓāmī, *Kulliyāt*, (1972), p. 686; Nezami, *La Sette Principesse*, 1967, pp. 96-100.

6. Folio 73 recto, 14.5 x 10 cm.
Bahrām Gūr is feasting in the golden pavilion. For the same theme depicted in an earlier style (1524-1525) see Chelkowski, *Mirror of the Invisible World*, 1975, p. 78, no. 7.

Niẓāmī, *Kulliyāt*, (1972), p. 715; Nezami, *La Sette Principesse*, 1967, pp. 125-135.

7. Folio 81 verso, 9.5 x 10 cm.
Bahrām Gūr is feasting in the green pavilion. For the same theme depicted in an earlier style see Chelkowski, *Mirror of the Invisible World*, 1975, p. 85, no. 8.

Niẓāmī, *Kulliyāt*, (1972), p. 726; Nezami, *La Sette Principesse*, 1967, pp. 135-147.

8. Folio 90 verso, 9 x 10 cm.
Bahrām Gūr is feasting in the red pavilion. For the same theme depicted in an earlier style see Chelkowski, *Mirror of the Invisible World*, 1975, p. 90, no. 9.

Niẓāmī, *Kulliyāt*, (1972), p. 737; Nezami, *La Sette Principesse*, 1967, pp. 147-161.

9. Folio 98 verso, 9.5 x 12 cm.
Bahrām Gūr is feasting in the turquoise pavilion. For the same theme depicted in an earlier style see Chelkowski, *Mirror of the Invisible World*, 1975, p. 97, no. 10.

Niẓāmī, *Kulliyāt*, (1972), p. 752; Nezami, *La Sette Principesse*, 1967, pp. 161-181.

10. Folio 114 verso, 9.5 x 11.5 cm.
Bahrām Gūr is feasting in the sandalwood pavilion. For the same theme depicted in an earlier style see Chelkowski, *Mirror of the Invisible World*, 1975, p. 101, no. 11.

Niẓāmī, *Kulliyāt*, (1972), p. 772; Nezami, *La Sette Principesse*, 1967, pp. 181-197.

11. Folio 128 recto, 9.5 x 11.5 cm.
Shown is a full page miniature of Bahrām Gūr feasting in the white pavilion. For the same theme depicted in an earlier style see Chelkowski, *Mirror of the Invisible World*, 1975, p. 107, no. 12.

Niẓāmī, *Kulliyāt*, (1972), pp. 789-804; Nezami, *La Sette Principesse*, 1967, pp. 197-211.

12. Folio 129 recto, 9.5 x 12 cm.
Bahrām Gūr is feasting in the white pavilion. See references to miniature no. 11 above.

13. Folio 141 verso, 9.5 x 10 cm.
Bahrām Gūr slays a dragon to whose cave he is led while chasing an onager. After he slays the dragon, the onager leads him into the interior of the dragon's cave where Bahrām Gūr discovers a fabulous treasure.

The miniature is misplaced in the manuscript and some of the pages around it are also in the wrong order. Several pages are wrongly restored with fragments of different incidents pasted together. The miniature shows Bahrām Gūr on foot while killing the dragon by sword. There are several

witnesses in the background though the story makes no mention of them. There are numerous depictions of this theme. Some of the most famous ones are: Stchoukine, *Les Peintures*, 1964, Plate XII (circa 1600), showing Bahrām Gūr on foot shooting an arrow into the dragon's mouth while a large audience watches in the background; Robinson, *Persian Miniature Paintings*, 1967, Plate 45, no. 119 (circa 1436), showing a large dragon covering the bottom of the page and Bahrām Gūr shooting at it over the tops of bushes and small trees; and Martin and Arnold, *The Nizami Ms.*, 1926, Plate 19, etc.

Niẓāmī, *Kulliyāt*, (1972), pp. 640-643; Nezami, *La Sette Principesse*, 1967, pp. 55-58.

V. Niẓāmī's *Khosrow and Shīrīn*

(JTS 1398)

This epic is an almost complete Judaeo-Persian copy of the famous Persian epic containing 142 folios and twelve miniatures which cannot, on stylistic grounds, date earlier than the beginning of the 17th century and which probably belong to the 18th century. Many of the miniatures are punctured on the outlines, attesting to their having been traced. The paper is light beige, each page containing two columns of text framed in a thin brown, dark blue, and gold border. The pages measure approximately 21.5 x 13.5 cm. The binding is of brown leather. The calligraphy is the same throughout and on many pages, (i.e. 22 verso, 31 verso, 34 verso, 43 verso, etc.), a distinct watermark of a winged creature is discernible; however, I was unable to identify it. The cross in the center of the design does indicate that the paper is of Western, possibly Italian, provenance. The present order of the pages of the manuscript is in great disarray. The listing below follows the proper order of the story, not the order of the folios. The identification of the contents of the miniatures on folios 63 verso, 65 verso, and 82 verso presents serious problems. For the Persian text see Niẓāmī, *Kulliyāt*, (1972). For a translation of the text see Nizâmî, *Le Roman de Chosroès et Chīrīn*, 1970.

1. Folio 106 verso, 11.2 x 11.8 cm.
Shāpūr, Khosrow's trusted artist friend (probably the male figure behind the hill), hangs the portrait of his master in a tree in the meadow where Shīrīn is sporting with her friends. Shīrīn, seated on the carpet, requests to see the picture and predictably falls in love with its subject. The servant girl climbing into the tree to get the picture makes this an original depiction of a well-known theme. For the same theme depicted in an earlier style (1495) see Robinson, *Persian Drawings*, 1965, p. 60, Plate 29.

Niẓāmī, *Kulliyāt*, (1972), pp. 161-165; Nizâmî, *Le Roman de Chosroès et Chīrīn*, 1970, p. 27ff.

2. Folio 130 verso, in two panels 5.4 x 11.5 cm. each
Top: Shīrīn, far right, is entertained by her companions during a hunting expedition.
Bottom: Gazelles, foxes and hares by a stream are not only the prey of the fair maidens above, but complement their grace and charm as well.

Niẓāmī, *Kulliyāt*, (1972), p. 162ff.; Nizâmî, *Le Roman de Chosroès et Chīrīn*, 1970, pp. 36-39.

3. Folio 133 verso, 12 x 11.8 cm.
This is probably the most popular theme of Iranian miniature painting. The bathing Shīrīn is observed, at first unawares, by Khosrow. At this point in the story the heroes are still ignorant of each other's identities.

This miniature is reproduced in color as the frontispiece of Mayer, *L'Art Juif en Terre de l'Islam*, 1959. There are countless earlier and later examples of this theme. Among these we single out Welch, *Royal Persian Manuscripts*, 1976, p. 82, Plate 25 (circa 1529-1545), Chelkowski, *Mirror of the Invisible World*, 1975, p. 26, no. 1 (circa 1524-1525) and a number of interesting provincial renderings in Robinson, *Persian Paintings*, 1976, p. 19, no. 76 (Turkman style, 1465); p. 51, no. 151 (Qazwīn, 1580); p. 107, no. 325 (Shīrāz, circa 1575); and p. 208, no. 1069 (Isfahan, circa 1605).

Niẓāmī, *Kulliyāt*, (1972), p. 176ff.; Nizâmî, *Le Roman de Chosroès et Chīrīn*, 1970, p. 39ff.

4. Folio 33 recto, 10.5 x 11.5 cm.
While listening to the sympathetic music of her female attendants, a melancholy Shīrīn, dressed in black, mourns the absence of news from Khosrow. The page is torn in half in the middle of the miniature and is clumsily repaired.

Niẓāmī, *Kulliyāt*, (1972), p. 238; Nizâmî, *Le Roman de Chosroès et Chīrīn*, 1970, pp. 95-96.

5. Folio 89 recto, 13 x 11.5 cm.
Farhād is visited by Shīrīn at Mount Bīsutūn where he is carrying out his labor of love, carving a tunnel through the mountain. Flowing by their feet is a stream of milk and its source, a special pool of milk, which Farhād built for Shīrīn.

This is also a favorite theme of Persian miniature painting. Some of the best examples are in Chelkowski, *Mirror of the Invisible World*, 1975, p. 36, no. 3 (circa 1524-1525); Binyon, *Persian Miniature Painting*, [1971], Plate XXXIII-B 42 (c) (circa 1410-1420); Robinson, *Persian Drawings*, 1965, p. 105, Plate 77 (circa 1481); and more provincial renderings in Robinson, *Persian Paintings*, 1976, p. 60, no. 184 (Qazwīn, circa 1580), and p. 61, no. 185 (Qazwīn, circa 1580).

Niẓāmī, *Kulliyāt*, (1972), p. 278ff.; Nizâmî, *Le Roman de Chosroès et Chîrîn*, 1970, p. 130ff.

6. Folio 92 verso, 14 x 11.5 cm.

During her visit to Bīsutūn Shīrīn's horse founders. Farhād picks it up and carries it back, with its rider, to Shīrīn's castle which is visible in the top right corner. For the same theme depicted in earlier styles see Binyon, *Persian Miniature Painting*, [1971], Plate CI-B 211 (b) (circa 1550)and a number of provincial renderings in Robinson, *Persian Paintings*, 1976, p. 32, no. 97 (Turkman style, circa 1505), p. 108, no. 326 (Shīrāz, circa 1575).

Niẓāmī, *Kulliyāt*, (1972), p. 278ff.; Nizâmî, *LeRoman de Chosroès et Chîrīn*, 1970, p. 131.

7. Folio 55 verso, 11 x 11.5 cm.

After a lengthy separation and many misunderstandings Khosrow comes to Shīrīn's castle and pleads for admittance. An implacable Shīrīn (second from right) listens to Khosrow's impassioned pleas. The miniature is torn in the middle and is clumsily repaired. For the same theme depicted in earlier styles see Robinson, *Persian Drawings*, 1965, p. 39, Plate 7 (circa 1400-1401); Arnold, *Painting in Islam*, 1965, Plate XIV (circa 1490), and Akimushkina and Ivanova, *Persidskiye Miniaturi*, 1968, no. 10 (Shīrāz, 1479) and no. 13 (Shīrāz, 1491).

Niẓāmī, *Kulliyāt*, (1972), pp. 309-314; Nizâmî,*Le Roman de Chosroès et Chîrîn*, 1970, pp. 157ff.

8. Folio 82, 12.5 x 11.2 cm.

Possibly this is Farhād killing a *dīv* while carving the tunnel. However no such incident is included in my Persian edition or translation of the epic. The crown and story would better suit Bahrām Gūr's feats, but the text does not belong with the *Haft Paykar* and the meter is the same as the meter of *Khosrow and Shīrīn*.

9. Folio 65 verso, 12.5 x 15 cm.

Possibly this is Khosrow hunting a lion which is preying on another animal, perhaps an onager? The theme is that of Bahrām Gūr's feats in the *Haft Paykar* (see description in IV, no. 2 above), but the meter is the same as the meter of *Khosrow and Shīrīn*. On the other hand, Khosrow's lion hunts occurred under different circumstances.

10. Folio 63 verso, 10.8 x 14.7 cm.

An incomplete sketch showing a warrior fighting or being aided by angels, while other angels look on. A slain angel is at the bottom of the page and the head of a black horse is in the left corner. The features are not yet drawn on the faces and the figures are covered only by a light wash. The meter of the text is that of *Khosrow and Shīrīn*, but I am unable to find the incident in my edition and translation of the epic.

11. Folio 15 recto, 11.2 x 16.5 cm.

Khosrow and Shīrīn are asleep when Shīruyah, Khosrow's son by another marriage, murders his father because he covets Khosrow's throne and Shīrīn's love. For the same theme depicted in an earlier style (1495) see Martin and Arnold, *The Nizami Ms.*, 1926, Plate 12.

Niẓāmī, *Kulliyāt*, (1972), p. 393; Nizâmî, *Le Romande Chosroès et Chīrīn*, 1970, pp. 228-229.

12. Folio 17 verso, 13 x 11.7 cm.

In the sight of her amazed and admiring attendants, Shīrīn stabs herself to death over Khosrow's tomb.

Niẓāmī, *Kulliyāt*, (1972), pp. 395-397; Nizâmî, *Le Roman de Chosroès et Chîrīn*, 1970, pp. 230-233.

VI. *Album Leaves*

(BL Or. 10194)

This is an album of verses by various poets, both classical Persian and Judaeo-Persian. It contains eighty folios and five full page miniatures which are actually portraits in the late Safavid portrait painting tradition. They cannot, however, date earlier than the end of the 18th century or, more likely, the beginning of the 19th century. The calligraphy is very poor throughout, hands change often, and frequently the writing is so faint as to be almost illegible. The paper is thick and yellowish and the manuscript contains some green paper as well. The pages measure 13.5 x 7 cm. The manuscript has a modern binding and it previously belonged to the Gaster collection where it had the number 776. It was acquired by the British Library in 1926.

1. Folio 8 verso, 11 x 5 cm.

This portrait, with Zand or Qājār style features, is of a girl with a bouquet of flowers. The dress butts into the margins and the page is lined in the middle, below the figure, as if it had originally been meant for the copying of verses. For roughly contemporaneous portraits with the same theme see Robinson, *Persian Paintings*, 1976, p. 240 (1233) [1817], p. 242 (1234) [1818], and p. 243 (1235) [1819].

2. Folio 28 verso, 12.5 x 5 cm.

A warrior in Qājār(?) attire is seated. As in the previous picture, the page is lined for verses. The theme is reminiscent, though very different in execution, of the warrior in Welch, *Wonders of the Age*, 1979, p. 198, no.77.

3. Folio 30 verso, 4 x 9 cm.

A girl with a bouquet of flowers is shown. The face, right shoulder and arm are damaged. The page is again lined for verses.

4. Folio 46 verso, 11.5 x 5 cm.

An old dervish with ax and begging bowl is shown. The face is almost completely rubbed out. The page is lined for verses. Compare the same theme and almost exact posture with the roughly contemporaneous portrait found in Robinson, *Persian Paintings*, 1976, p. 239 (1232) [1816].

5. Folio 61 verso, 11.5 x 5 cm.

A young dervish with stick and begging bowl is shown. See Robinson, *Persian Paintings*, 1976, p. 239 (1232) [1816].

VII. Shāhīn's *Ardashīr Nāma*

(SPK or. qu. 1680)

This manuscript is a complete copy of Shāhīn's epic composed around 1330-1332. It contains 203 folios and twenty-four miniatures. It is evenly copied by the same hand on paper measuring 15.5 x 21.5 cm. Many pages contain a watermark, a cross placed in the center of an oval, which I was unable to identify; it is most likely of West European provenance. The binding is modern half-leather, probably provided by the Preussischer Staatsbibliothek which probably also restored some of the pages. The beginning and ending of the manuscript are missing. This manuscript was acquired by the Preussischer Staatsbibliothek in 1928.

Striedl, "Die Miniaturen," in *Forschungsberichte* 10 (1966): 119-133) analyses the miniatures in the manuscript. Based on this analysis he dates the manuscript (p. 132) as belonging to the middle of the seventeenth century in the period of the followers of the Isfahan school. According to Professor Stuart C. Welch, the miniatures are more likely the product of the latter part of the seventeenth century. Both the figure drawing and the use of color are reminiscent of the style of Muʿīn Musawwir who flourished during the second half of the seventeenth century. It is known that his style had become popular among the painters of the bazaars.

The epic is discussed and described in Bacher, *Zwei Jüdisch-Persische Dichter*, 1907, pp. 43-66. Part of the epic is edited in Netzer, *Muntakhab*, 1973, pp. 107-179. A textual and linguistic analysis of the epic as well as an edition of the first twenty-two chapters and résumés of the rest are provided by Blieske, *Ardašīr-Buch*, 1966, pp. 45-186. References are here given to the more recent studies of Striedl, Netzer and Blieske. Because the folios are bound in the wrong order, this study, like the Striedl analysis, classifies the miniatures according to their content.

1. Folio 5 recto, 14.6 x 12.2 cm.

Shah Ardashīr or, as he is frequently called in the epic, Shah Bahman, is hunting a lion with bow and arrow. Hares and gazelles flee from the hunting ground. There are four appreciative spectators behind the pink rocks. Ardashīr's horse leaps through the border adding to the sense of animation that imbues both horse and rider. A hound accompanies the shah. Striedl, "Die Miniaturen," in *Forschungsberichte* 10 (1966): 125, notes that there is an inconsistency here between the text and the picture. According to the text, Ardashīr hunted on foot, his mount staying behind in dread. Throughout the manuscript costumes and headdresses are typical of the seventeenth century.

Striedl, "Die Miniaturen," in *Forschungsberichte* 10 (1966): 123, no. 1; Netzer, *Muntakhab*, 1973, pp. 124-126; Blieske, *Ardašīr-Buch*, 1966, chap. 10, pp. 57-58.

2. Folio 11 recto, 12.8 x 10.5 cm.

Shah Ardashīr feasts upon ascending the throne.

Striedl, "Die Miniaturen," in *Forschungsberichte* 10 (1966): 123, no.2; Netzer, *Muntakhab*, pp. 132-134; Blieske, *Ardašīr-Buch*, 1966, chap. 134, pp. 63-64.

3. Folio 29 recto, 16 x 11 cm.

Bishūtan, the shah's vizier, gathers all the lovely maidens of the realm into the presence of Shah Ardashīr so that he may choose a new wife and companions after the death of Queen Vashti (Esther 2:8-9).* The backdrop with animal designs appears in many of the miniatures of this manuscript and seems to have been present in Persian miniatures at least since the middle of the sixteenth century. For some fine examples of such backdrops see Welch, *Royal Persian Manuscripts*, 1976, Plate 26 and Plate 38. This miniature is reproduced in color in Gutmann, *Hebrew Manuscript Painting*, 1978, Plate 3 and in black and white in Striedl, "Die Miniaturen," in *Forschungsberichte* 10 (1966): 129, Plate XXXV.

*All Biblical references are to *The Holy Scriptures* (Philadelphia: The Jewish Publication Society of America, 1955).

Striedl, "Die Miniaturen," in *Forschungsberichte* 10 (1966): 123, no. 3; Blieske, *Ardašīr-Buch*, 1966, résumé chap. 30, p. 149.

4. Folio 54 recto, 16.2 x 13.2 cm.

Haman, the large figure with the red cane on the left, supervises the construction of his palace in Susa. This rather primitive construction invites comparison with Bihzād's famous "Construction of the Castle of Khawarnaq," (circa 1494), reproduced in Gray, *Persian Paintings*, 1977, p. 116. This miniature is reproduced in black and white in Gutmann, "Judeo-Persian Miniatures," in *Studies* 8 (1968): 65, Figure 5.

Striedl, "Die Miniaturen," in *Forschungsberichte* 10 (1966): 123, no. 4; Blieske, *Ardašīr-Buch*, 1966, résumé chap. 44, p. 154.

5. Folio 82 recto, 15.6 x 14 cm.

A large plane tree extending through the margins of the miniature is, as it were, embraced or propped by three angels. A small inscription on the left outside the frame identifies the scene as the uprooting of Shah Ardashīr's garden. The reference is to the Talmudic story (Megillah 16a) in which God, in order to intensify Shah Ardashīr's (Ahashuerosh's) anger against Haman, sent "ten angels in the guise of Haman's sons to fell down tress in the royal park. When Ahashuerosh turned his eyes toward the interior of the park, he saw the ruthless destruction of which they were guilty..." There are several other variations of the story, all mentioned by Ginzberg, *Legends*, 1913, vol. IV, p. 442 and vol. VI, p. 478, no. 181.

The plane tree is one of the most frequently found natural objects in Persian miniatures and is often referred to in poetry as well. Among the numerous excellent depictions one could cite we single out Binyon, *Persian Miniature Painting*, 1971, Plate LXXI-B 110 (c), (1548) and, perhaps the most stunning example of a plane tree, in Welch, *Imperial Mughal Painting*, 1978, Plate 25 (circa 1610).

Numerous similar examples of angels with Mongol top knots can also be found in Persian miniature painting. Some of the best examples are in Binyon, *Persian Miniature Painting*, Plate LXXXII-A 119 (b), (1504), Plate XC-A 139 (a), (1531), and Plate XCVIII-a 101, (1501).

Striedl, "Die Miniaturen," in *Forschungsberichte* 10 (1966): 123, no. 5; Blieske, *Ardašīr-Buch*, 1966, résumé chap. 60, p. 163.

6. Folio 88 verso, 14.9 x 12.5 cm.

The Jews are killing the followers of Haman (Esther 9:5-6, 15). A strange gleeful animal in the top right corner observes the scene.

Striedl, "Die Miniaturen," in *Forschungsberichte* 10 (1966): 123, no. 6; Blieske, *Ardašīr-Buch*, 1966, résumé chap. 64, p. 165.

7. Folio 93 recto, 15.7 x 15 cm.

Haman's ten sons are hanged on the gallows he intended for the Jews. Archers aim at the victims (Esther 9:13-14). This unusual form of execution can be compared with Plate LXV, "Execution de Mazdak et de ses partisans," (circa 1648), at least in the concept of shooting arrows at the victims, reproduced in Stchoukine, *Les Peintures*, 1964. This miniature is reproduced in color in Gutmann, *Hebrew Manuscript Painting*, 1978, Plate 4 and in black and white in his "Judeo-Persian Miniatures," in *Studies* 8 (1968): 69, Figure 9.

Striedl, "Die Miniaturen," in *Forschungsberichte* 10 (1966): 123, no. 7; Blieske, *Ardašīr-Buch*, 1966, résumé chap. 61, p. 164.

8. Folio 98 verso, 13.5 x 12.5 cm.

Shah Ardashīr gathers the learned men of his age to be the tutors of his son Kūrush (Cyrus). Kūrush, offspring of Shah Ardashīr and Queen Esther, is seated at the bottom right. A European and an Indian are among the prince's tutors.

Striedl, "Die Miniaturen," in *Forschungsberichte* 10 (1966): 123, no. 8; Blieske, *Ardašīr-Buch*, 1966, résumé chap. 70, p. 167.

9. Folio 99 verso, 10.6 x 12.5 cm.

Shah Ardashīr is hunting with his two sons Shīrū and Kūrush. This is the fateful hunt during which Shīrū loses his way while pursuing an enchanted gazelle.

Striedl, "Die Miniaturen," in *Forschungsberichte* 10 (1966): 123, no. 9; Blieske, *Ardašīr-Buch*, 1966, résumé chap. 71, p. 167.

10. Folio 102 recto, 13.5 x 12.5 cm.

During the first night of his separation from the royal hunt Shīrū valiantly kills two lions in a feat reminiscent of that of his father (see no. 20 below). The plane tree is reminiscent of the one in no. 5 above.

Striedl, "Die Miniaturen," in *Forschungsberichte* 10 (1966): 123, no. 10; Blieske, *Ardašīr-Buch*, 1966, résumé chap. 71, p. 167.

11. Folio 103 recto, 12.9 x 13.2 cm.

On the tenth day of his wanderings Shīrū is attacked by a pack of strange wolves. In the text he hides in a tree because his quiver is empty, and from there observes the destruction of the winged wolves by a fire-spitting dragon. In the miniature, however, he is portrayed as actively defending himself from the wolves when the dragon appears. Another discrepancy between the story and the illustration is that in the former Shīrū is entirely alone, not accompanied by the amazed attendant who guards his horse in the left corner of the miniature. These discrepancies have already been noted in Striedl,"Die Miniaturen," in *Forschungsberichte* 10 (1966): 125. This miniature is reproduced in black and white in Striedl, "Die Miniaturen," in *Forschungsberichte* 10 (1966): 128, Plate XXXIV.

Striedl, "Die Miniaturen," in *Forschungsberichte* 10 (1966): 123, no. 11; Blieske, *Ardašīr-Buch*, 1966, résumé chap. 72, p. 168.

12. Folio 107 verso, 15.9 x 10.3 cm.

While pursuing a white gazelle shown at the top of the picture, Shīrū falls asleep near a pool. He is transported from there to the fairy land of Chīn (China) by the fairy Queen Mahzād, portrayed here in angelic form. This miniature contains curious thematic and compositional problems: Shīrū's eyes are wide open though he is supposed to be fast asleep; the formal pool, complete with fish and waves, is not usually encountered in the wilderness, and it occupies an inordinately large part of the bottom of the page; and half of Shīrū's horse awkwardly occupies the left bottom corner of the page.

Striedl, "Die Miniaturen," in *Forschungsberichte* 10 (1966): 123, no. 12; Blieske, *Ardašīr-Buch*, 1966, résumé chap. 72, pp. 167-168.

13. Folio 109 verso, 16 x 10.3 cm.

After his abduction Shīrū finds himself in a wondrous palace near a golden pool inhabited by exotic fish. Within the palace is a golden throne and the setting for a feast. Shīrū's amazement is registered by the gesture characteristic of such feelings in Iranian miniatures, biting of the index finger. His golden attire complements the pink background and orange floor. The architecture of the palace is completely unreal.

Striedl, "Die Miniaturen," in *Forschungsberichte* 10 (1966): 123, no. 13; Blieske, *Ardašīr-Buch*, 1966, résumé chap. 73, pp. 168-169.

14. Folio 113 verso, 11.9 x 11.2 cm.

Shīrū and the fairy Queen Mahzād are feasting in one of her gardens. The palace walls are visible in the background. Pomegranates, oranges, cypress and maple trees symbolize the beauty and fertility of the garden while the two birds near the heads of the heroes no doubt duplicate their language of love. Note also that Shīrū is no longer in his warrior garb but wears a homely "negligee."

Striedl, "Die Miniaturen," in *Forschungsberichte* 10 (1966): 123, no. 14; Blieske, *Ardašīr-Buch*, 1966, résumé chap. 75, p. 170.

15. Folio 165 recto, 14.9 x 10.3 cm.

Another feast scene with Shīrū and Mahzād in her white palace. The figures as well as the unlikely architecture are more coarsely executed, perhaps by a different hand. The faces of the two musicians at the bottom of the picture are badly damaged.

Striedl, "Die Miniaturen," in *Forschungsberichte* 10 (1966): 123, no. 15; Blieske, *Ardašīr-Buch*, 1966, résumé chap. 88, p. 177.

16. Folio 167 recto, 15.6 x 11.7 cm.

After giving birth to her son by Shīrū, Mahyār, Mahzād is attended by her servants. The baby sleeps peacefully at her side. The faces of the female attendants are poorly drawn and there is some confusion in the painter's mind about what to do with Mahzād's wings.

Striedl, "Die Miniaturen," in *Forschungsberichte* 10 (1966): 123, no. 16; Blieske, *Ardašīr-Buch*, 1966, résumé chap. 77, p. 171.

17. Folio 147 verso, 16 x 10.2 cm.

Shah Ardashīr consults his astrologers regarding Shīrū's fate. They inform him of Shīrū's circumstances in Chīn. The pink backdrop with grey bird and animal designs is richer here than in the other miniatures and the figures are very finely drawn. The Indian sage at the bottom right corner is particularly attractive. Two books can be seen before him; one of them is open with some lines in Arabic script that are, however, unintelligible.

Striedl, "Die Miniaturen," in *Forschungsberichte* 10 (1966): 123, no. 17; Blieske, *Ardašīr-Buch*, 1966, résumé chap. 80, p. 172.

18. Folio 149 verso, 16.1 x 10.1 cm.

During a hunt Shah Ardashīr decides to found a new city called Ardashīrābād. The miniature plan of the city, meant perhaps for the actual city, is at the bottom center of the picture. The young servant attending the shah is almost identical with the one waiting on him and his guests in folio 146 verso (no. 19 below).

Striedl, "Die Miniaturen," in *Forschungsberichte* 10 (1966): 123, no. 18; Blieske, *Ardašīr-Buch*, 1966, résumé chap. 81, pp. 172-173.

19. Folio 146 verso, 16.1 x 10.6 cm.

Shīrū and Mahzād at the right side of Shah Ardashīr are entertained by him during their visit to Iran. Mahzād seems to have tucked in her wings for the occasion. Striedl, "Die Miniaturen," in *Forschungsberichte* 10 (1966): 125, points out that there exists a discrepancy here between the text and the illustration: Mahzād is not actually present at the feast according to the text, though she is in Iran with Shīrū.

Striedl, "Die Miniaturen," in *Forschungsberichte* 10 (1966): 123, no. 19; Blieske, *Ardašīr-Buch*, 1966, résumé chap. 82, pp. 173-174.

20. Folio 123 verso, 16.2 x 14.1 cm.

Shah Ardashīr hunts two lions in a feat paralleling that of Shīrū (see no. 10 above). In the text only the lioness is killed by an arrow; the lion is killed by a sword.

Striedl, "Die Miniaturen," in *Forschungsberichte* 10 (1966): 124, no. 20; Blieske, *Ardašīr-Buch*, 1966, résumé chap. 86, p. 177.

21. Folio 126 verso, 18.3 x 10.3 cm.

Shīrū and his consort Mahzād are feasting in their palace. Once again, as in folio 113 verso, the harmony between the lovers is echoed, not only by the setting, but by the presence of warbling birds on the backdrop as well.

Striedl, "Die Miniaturen," in *Forschungsberichte* 10 (1966): 124, no. 21; Blieske, *Ardašīr-Buch*, 1966, résumé chap. 76, p. 171.

22. Folio 171 recto, 7.5 x 10.8 cm.

Shah Ardashīr and an attendant are standing at the shore of the lake in which Shīrū is seen to have drowned. The lake is teeming with fish while the falcon, whose pursuit caused Shīrū's fall into the water, is still hovering over the scene. In the story itself the shah does not personally witness Shīrū's death.

Striedl, "Die Miniaturen," in *Forschungsberichte* 10 (1966): 124, no. 22; Blieske, *Ardašīr-Buch*, 1966, résumé chap. 93, pp. 180-181.

23. Folio 173 verso, 16.3 x 12.8 cm.

Shah Ardashīr meets his death in combat with a dragon that swallows him. The dragon also dies, but the shah's attendants are unable to save their master.

Striedl, "Die Miniaturen," in *Forschungsberichte* 10 (1966): 124, no. 23; Blieske, *Ardašīr-Buch*, 1966, résumé chap. 101, pp. 183-185.

24. Folio 184 recto, 16 x 11 cm.

After the death of Shah Ardashīr, his second son Kūrush ascends the throne.

Striedl, "Die Miniaturen," in *Forschungsberichte* 10 (1966): 124, no. 24.

VIII. Shāhīn's *Ardashīr Nāma*

(JTS 40919)

This manuscript is a complete copy of Shāhīn's epic containing 164 folios and thirty-three miniatures, many of which are quite damaged. It is copied evenly by the same hand except in a few places, i.e. folios 76 recto, 77 verso, 79 recto, 80 verso, and 164 recto and verso, where the script is in a different, unpracticed hand. The pages measure approximately 24 x 16.5 cm. and the paper is light brown and very smooth. Each page has borders lined with thin gold, black, blue, red and brown lines. Many of the folios contain a distinct watermark, shaped somewhat like a fish on its tail, which I was unable to identify or date. The manuscript has been restored as is evident from many pages and the new binding. It was purchased by Izmir Lian on March 4, 1915. In the present binding the story and the pictures are entirely out of order, so I have followed the order of the narrative as established by H. Striedl in his analysis of the other illustrated *Ardashīr Nāma* (SPK or. qu. 1680). Since beginning and ending pages are missing it is difficult to date the manuscript with great accuracy. The prevalent usage of the pink backdrops with animal designs, the poor design and stereotyped positions of the characters, the costumes and the elongated bodies argue for a date no earlier than the second half of the seventeenth century and possibly well into the eighteenth century. Its relationship with the other illustrated *Ardashīr Nāma* remains to be determined.

The epic is discussed and described by Bacher, *Zwei Jüdisch-Persische Dichter*, 1907, pp. 43-66. Part of the epic is edited in Netzer, *Muntakhab*, 1973, pp. 107-179. A textual and linguistic analysis of the epic as well as an edition of the first twenty-two chapters and résumés of the rest are

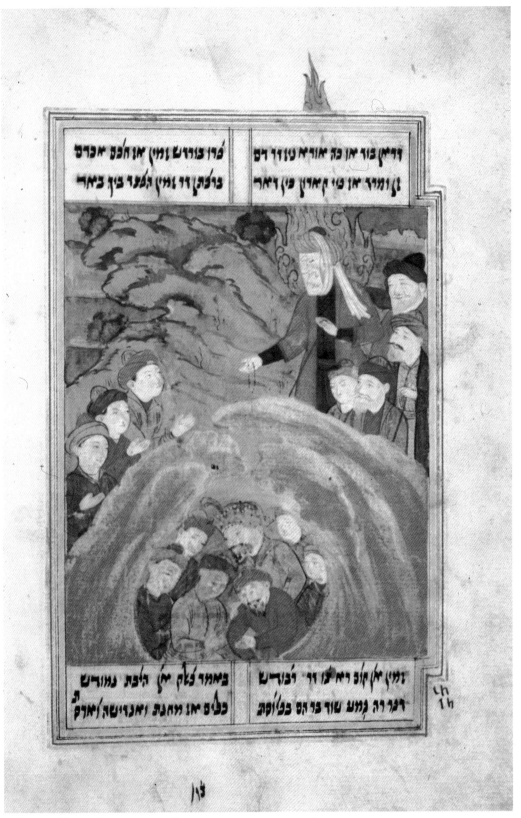

Collection of the Israel Museum, Jerusalem

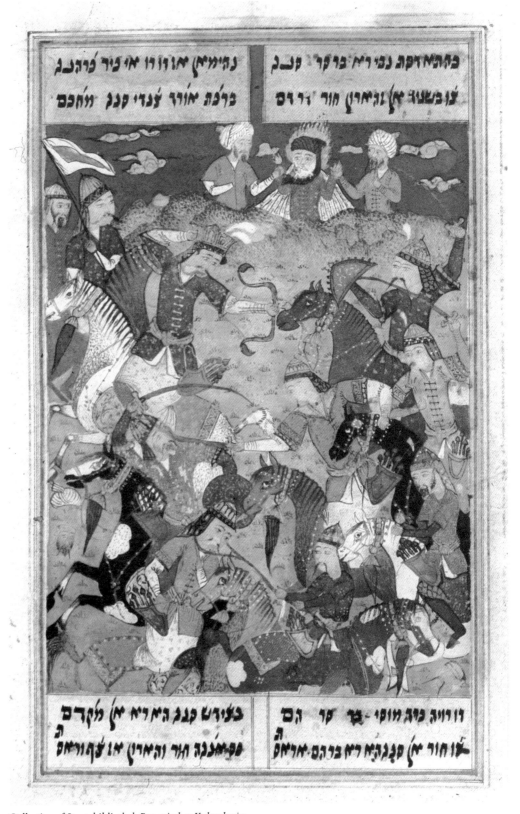

Collection of Staatsbibliothek Preussischer Kulturbesitz

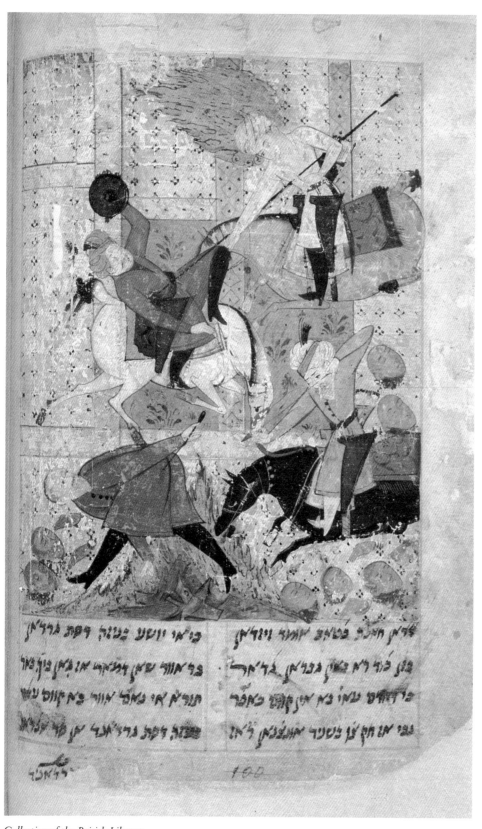

צראן חולה בטראב שומאר ווזראן | בּן כּוד רא באן גרדאן גּרי'אר | בּודידם עמו בא אין קמאר בּאמר | גּבי אן חק צן בּשער אמאנגּאן ל'אן

בּו'או ווסע בּנוק דפת גרדאן | בדּאוור שאן דמאקּא אן בּאן בּין בּאר | תוראא אי גּאמר אוור בּא קווס עש | שבהר דפת גרדיאגר אן פר שלימא

1. Folio 33 recto, 13.2 x 15.2 cm.

Shah Ardashīr ascends the throne amidst feasting and rejoicing. His face as well as some verses above it are rubbed out. Compare with SPK or. qu. 1680, folio 11 recto, no. 2.

Striedl, "Die Miniaturen," in *Forschungsberichte* 10 (1966): 123, no. 2; Netzer, *Muntakhab*, 1973, pp. 132-134; Blieske, *Ardašīr-Buch*, 1966, chap. 13, pp. 63-64.

2. Folio 78 recto, 15.3 x 15.2 cm.

Shah Ardashīr entertains grandees from Rūm (Anatolia/Byzantium) and Qābūl (Afghanistan).

Blieske, *Ardašīr-Buch*, 1966, résumé chaps. 25-26, pp. 145-146.

3. Folio 138 verso, 14.7 x 14.5 cm.

Shah Ardashīr is entertaining foreign princes and bestows generous gifts upon them.

Blieske, *Ardašīr-Buch*, 1966, résumé chap. 25, pp. 145-146.

4. Folio 13 recto, 15 x 18 cm.

Shah Ardashīr's vizier, Bishūtan, gathers the loveliest maids of the kingdom so that the Shah may choose a spouse and companion from among them after the death of Queen Vashti (Esther 2:8-9). Compare with SPK or. qu. 1680, folio 29 recto, no. 3.

Striedl, "Die Miniaturen, " in *Forschungsberichte* 10 (1966): 123, no. 3; Blieske, *Ardašīr-Buch*, 1966, résumé chap. 30, p. 149.

5. Folio 8 verso, 12.4 x 15 cm.

Shah Ardashīr investigates the beauty of prospective companions in the presence of entertainers. Compare with SPK or. qu. 1680, folio 29 recto, no. 3.

Striedl, "Die Miniaturen," in *Forschungsberichte* 10 (1966): 123, no. 3; Blieske, *Ardašīr-Buch*, 1966, résumé chaps. 30-31, p. 149.

6. Folio 4 verso, 13.2 x 15.1 cm.

In the presence of dancers and musicians, Shah Ardashīr is entertained by the females of his harem. Compare with SPK or. qu. 1680, folio 29 recto, no. 3.

Striedl, "Die Miniaturen," in *Forschungsberichte* 10 (1966): 123, no. 3; Blieske, *Ardašīr-Buch*, 1966, résumé chaps. 30-31, p. 149.

7. Folio 44 verso, 14.3 x 15 cm.

Shah Ardashīr gives poison to the servants who tried to poison him. The servants' plot was discovered by Mordechai (Esther 2:21-23).

Blieske, *Ardašīr-Buch*, 1966, résumé chaps. 41-42, pp. 152-154.

8. Folio 20 verso, 15 x 13.5 cm.

Shah Ardashīr bestows the vizierate on Haman who is shown here kissing the royal foot and robe (Esther 3:1). Male dancers and attendants are present at the occasion. This miniature is reproduced in black and white in Gutmann, "Judeo-Persian Miniatures," in *Studies* 8 (1968): 67, Figure 7.

Blieske, *Ardašīr-Buch*, 1966, résumé chap. 47, p. 155.

9. Folio 36 recto, 14.2 x 15.5 cm.

Riding under a canopy, Haman as Grand Vizier inspects the construction of his palace in Susa. Compare with SPK or. qu. 1680, folio 54 recto, no. 4. This miniature is reproduced in black and white in Gutmann, "Judeo-Persian Miniatures," in *Studies* 8 (1968): 66, Figure 6.

Striedl, "Die Miniaturen," in *Forschungsberichte* 10 (1966): 123, no. 4; Blieske, *Ardašīr-Buch*, 1966, résumé chap. 44, p. 154.

10. Folio 84 recto, 13.7 x 15.5 cm.

Queen Esther is entertaining Shah Ardashīr in the presence of Haman and other grandees (Esther 5:5). The miniature is badly damaged and almost the entire bottom half of the text is torn off.

Blieske, *Ardašīr-Buch*, 1966, résumé chap. 54, p. 159.

11. Folio 126 recto, 9.5 x 16.3 cm.

Two angels are trying to uproot a tree in Shah Ardashīr's garden. The miniature is badly damaged; the left bottom half is torn off. Compare the picture and story with SPK or. qu. 1680, folio 82 recto, no. 5.

Striedl, "Die Miniaturen," in *Forschungsberichte* 10 (1966): 123, no. 5; Blieske, *Ardašīr-Buch*, 1966, résumé chap. 60, p. 163.

12. Folio 86 verso, 15 x 17 cm.

Haman is hung upon the shah's orders. The shah is actually present here at the execution. A soldier is shooting at the body and the henchman's motions are very dynamic. The miniature is badly damaged and the right hand corner of the page is torn off. Compare with SPK or. qu. 1680, folio 93 recto, no. 7, where only the sons of Haman are executed. This miniature is reproduced in black and white in Gutmann," Judeo-Persian Miniatures," in *Studies* 8 (1968): 68, Figure 8.

Striedl, "Die Miniaturen," in *Forschungsberichte* 10 (1966): 123, no. 7; Blieske, *Ardašīr-Buch*, 1966, résumé chap. 61, p. 164.

13. Folio 154 recto, 15.5 x 14.5 cm.

Queen Esther gives birth to Kūrush (Cyrus), her son by Shah Ardashīr. The miniature is badly damaged; the left bottom corner as well as the bottom of the page are torn off. This miniature is reproduced in black and white in Gutmann, "Judeo-Persian Miniatures," in *Studies* 8 (1968): 70, Figure 10, where the folio number is incorrectly cited as 54 recto.

Netzer, *Muntakhab*, 1973, pp. 170-172; Blieske, *Ardašīr-Buch*, 1966, résumé chap. 69, p. 166.

14. Folio 68 recto, 14.5 x 16.2 cm.

Shah Ardashīr gathers the wise men of the age to educate his son Kūrush. The young prince is barely visible as the smudged figure on the smaller throne. Compare with SPK or. qu. 1680, folio 98 verso, no. 8.

Striedl,"Die Miniaturen," in *Forschungsberichte* 10 (1966): 123, no. 8; Blieske, *Ardašīr-Buch*, 1966, résumé chap. 70, p. 167.

15. Folio 141 recto, 16.5 x 13.8 cm.

Lost during a hunt, Shīrū, Shah Ardashīr's eldest son, falls asleep by a pool. He is whisked off by the fairy Queen Mahzād to her enchanted realm of Chīn. As opposed to manuscript SPK or. qu. 1680, this is the only representation of Queen Mahzād with wings in this entire manuscript. This miniature is badly damaged; the two sides are torn off.

The posture of the flying Queen Mahzād echoes the illustration of many lovely angels in famous Iranian miniatures. One is particularly reminded of the flying angels in Welch, *Royal Persian Manuscripts*, 1976, Plate 4 (circa 1522), in Gray, *Persian Painting*, 1977, p. 107 (circa 1480), and in Robinson, *Persian Paintings*, 1976, p. 126, no. 378 (16th century). Compare with SPK or. qu. 1680, folio 107 verso, no. 12.

Striedl,"Die Miniaturen," in *Forschungsberichte* 10 (1966): 123, no. 12; Blieske, *Ardašīr-Buch*, 1966, résumé chap. 72, pp. 167-168.

16. Folio 116 verso, 15.2 x 12.5 cm.

Shīrū beholds wonders in the chambers of Queen Mahzād's palace. His amazement is illustrated by the various gestures of his hand. Compare with SPK or. qu. 1680, folio 101 verso, no. 13.

Striedl,"Die Miniaturen," in *Forschungsberichte* 10 (1966): 123, no. 13; Blieske, *Ardašīr-Buch*, 1966, résumé chap. 74, p. 169.

17. Folio 111 verso, 16.5 x 13 cm.

Shīrū and Queen Mahzād are enjoying a walk in her gardens. These standing figures are faintly reminiscent of late Safavid full length portraits. They are, however, far more primitive. Compare with SPK or. qu. 1680, folio 113 verso, no. 14.

Striedl,"Die Miniaturen," in *Forschungsberichte* 10 (1966): 123, no. 14; Blieske, *Ardašīr-Buch*, 1966, résumé chap. 75, p. 170.

18. Folio 81 verso, 14.5 x 14.5 cm.

Queen Mahzād and Shīrū are feasting in her palace in Chīn. Compare with SPK or. qu. 1680, folio 165 recto, no. 15.

Striedl,"Die Miniaturen," in *Forschungsberichte* 10 (1966): 123, no. 15; Blieske, *Ardašīr-Buch*, 1966, résumé chap. 74, p. 169.

19. Folio 56 recto, 15.7 x 15.5 cm.

Shīrū and Queen Mahzād continue their entertainment in her palace. The attendant behind Shīrū appears in several miniatures, i.e. folio 95 verso. Compare with SPK or. qu. 1680, folio 165 recto, no. 15.

Striedl,"Die Miniaturen," in *Forschungsberichte* 10 (1966): 123, no. 15; Blieske, *Ardašīr-Buch*, 1966, résumé chap. 76, p. 171.

20. Folio 40 recto, 15 x 14.5 cm.

Queen Mahzād, the fairy wife of Shīrū, is giving birth to their son Mahyār. The story tells of the birth of only one son, but here a baby is being bathed in the foreground while another is being born. The theme and its execution are similar to that of folio 154 recto (no. 13 above). Compare with SPK or. qu. 1680, folio 167 recto, no. 16.

Striedl,"Die Miniaturen," in *Forschungsberichte* 10 (1966): 123, no. 16; Blieske, *Ardašīr-Buch*, 1966, résumé chap. 77, p. 171.

21. Folio 133 recto, 13.8 x 15.7 cm.

Shah Ardashīr realizes that Shīrū's absence means that his son was lost during their last hunting expedition.

Blieske, *Ardašīr-Buch*, 1966, résumé chap. 79, p. 172.

22. Folio 95 recto, 12.5 x 14.9 cm.

Shah Ardashīr consults his astrologers concerning the whereabouts of Shīrū. The miniature is badly damaged and the right bottom corner of the text is torn off. Compare with SPK or. qu. 1680, folio 147 verso, no. 17.

Striedl,"Die Miniaturen," in *Forschungsberichte* 10 (1966): 123, no. 17; Blieske, *Ardašīr-Buch*, 1966, résumé chap. 80, p. 172.

23. Folio 22 verso, 15 x 14.8 cm.

In the hope of finding Shīrū, Shah Ardashīr leaves his royal residence of Shūshtar and heads with his retinue towards Mt. Ālwand.

Blieske, *Ardašīr-Buch*, 1966, résumé chap. 81, p. 172.

24. Folio 31 recto, 15.5 x 14.2 cm.

During a hunting expedition Shah Ardashīr founds the new city of Ardashīrābād. Compare with SPK or. qu. 1680, folio 149 verso, no. 18.

Striedl,"Die Miniaturen," in *Forschungsberichte* 10 (1966): 123, no. 18; Blieske, *Ardašīr-Buch*, 1966, résumé chap. 81, pp. 172-173.

25. Folio 50 recto, 14.2 x 15 cm.

Shīrū and Queen Mahzād entertain Shah Ardashīr and his grandees.

Blieske, *Ardašīr-Buch*, 1966, résumé chap. 83, pp. 174-175.

26. Folio 150 verso, 14.9 x 15.2 cm.

Shah Ardashīr and Shīrū, but not Queen Mahzād, as claimed in the ʿunwān or chapter heading, are going to see the shah's newly built city of Mar Ardashīr. This is not to be confused with the newly built city of Ardashīrābād in folio 31 recto (no. 24 above).

Blieske, *Ardašīr-Buch*, 1966, résumé chap. 85, p. 176.

27. Folio 28 recto, 15.8 x 15 cm.

Shah Ardashīr kills two lions in the second of such feats. The amazed attendant on the left, with the blue turban, also appears in folio 6 recto (no. 28 below). Compare with SPK or. qu. 1680, folio 123 verso (no. 20 above).

Striedl,"Die Miniaturen," in *Forschungsberichte* 10 (1966): 124, no. 20; Blieske, *Ardašīr-Buch*, 1966, résumé chap. 86, p. 177.

28. Folio 6 recto, 16.1 x 14.5 cm.

While still living with Queen Mahzād, Shīrū gets lost during a hunting expedition and is taken prisoner by one of his enemies, Shamākha the magician. The attendant on the right, still amazed, appears also in folio 28 recto (no. 27 above).

Blieske, *Ardašīr-Buch*, 1966, résumé chap. 88, p. 178.

29. Folio 96 verso, 13.8 x 15 cm.

Shīrū is abducted by the magician Shamākha and is taken to the legendary Mt. Qāf. The magician in his angelic guise and posture is practically identical with Queen Mahzād in folio 141 recto (no. 15 above).

Blieske, *Ardašīr-Buch*, 1966, résumé chap. 88, p. 178.

30. Folio 93 verso, 14.3 x 15 cm.

Shīrū drowns during a hunting expedition. His attendants watch helplessly, as do his horse and the wild animals in the picture. Shīrū appears to be swimming but, according to the text, he is actually drowning. Compare with SPK or. qu. 1680, folio 171 recto (no. 22 above).

Striedl, "Die Miniaturen," in *Forschungsberichte* 10 (1966): 124, no. 22; Blieske, *Ardašīr-Buch*, 1966, résumé chap. 93, pp. 180-181.

31. Folio 100 recto, 13.7 x 14.5 cm.

Queen Mahzād, in mourning, requests Shah Ardashīr's permission to take Shīrū's coffin, shown here in the foreground, back with her to Chīn. The color black dominates the picture.

Blieske, *Ardašīr-Buch*, 1966, résumé chap. 95, p. 181.

32. Folio 131 verso, 14.8 x 14 cm.

Queen Mahzād apologizes to Shah Ardashīr for demanding Shīrū's coffin, but obtains her request. Their difference of opinion is eloquently depicted by their gestures.

Blieske, *Ardašīr-Buch*, 1966, résumé chap. 99, p. 182.

33. Folio 121 recto, 14 x 15 cm.

Shah Ardashīr kills a dragon and in the process is himself killed by it. Only the first half of the action is illustrated here. Compare with SPK or. qu. 1680, folio 173 verso (no. 23 above).

Striedl, "Die Miniaturen," in *Forschungsberichte* 10 (1966): 124, no. 23; Blieske, *Ardašīr-Buch*, 1966, résumé chap. 101, pp. 183-185.

IX. Shāhīn's *Mūsā Nāma*

(IM 180/54)

This is a complete manuscript of Shāhīn's epic versifying much of Exodus, Leviticus, Numbers and Deuteronomy, emphasizing the action and omitting most of the legal parts. It leans heavily on Jewish and Muslim legendary material. It was written in Judaeo-Persian around 1327. The manuscript contains 262 folios (folio 241 is blank and of a different paper) and nineteen miniatures. The non-illuminated pages, some of which have floral vignettes, have text frames measuring approximately 9.7 x 15.6 cm. The volume is fully leather bound with some blind tooling. The paper is uniform throughout, watermarked similar to Churchill No. 475 (with initials S.P.D.A.). It was purchased by the Israel Museum in 1966. The approximate size of each page is 15.6 x 22.85 cm. The colophon indicates that it was copied on the First of Av of 5446 (1686) by Nehemiah ben Amshal of Tabriz. It is very likely that he is also the copyist of the small

fragment of the epic found in the Staatsbibliothek Preussischer Kulturbesitz, or. oct. 2885. The last page contains other dates, possibly from former owners, among them 1666(?) and 1706. While Moses' face is veiled in most of the manuscript in the fashion characteristic of depicting Muḥammad and other Muslim holymen, it is not done consistently and this is puzzling. I note the specific pictures where his face is not veiled. This feature may, however, indicate the hand of different painters orateliers. The epic is discussed and described in Bacher, *Zwei Jüdisch-Persische Dichter*, 1907, pp. 40-43. Part of the epic is edited in Netzer, *Muntakhab*, 1973, pp. 9-58.

1. Folio 12 recto, 12 x 15.6 cm.

Afraid of Pharaoh's men (top left), Moses' mother casts the baby Moses into a flaming oven. Moses' sister Miriam is shown despairing in the left corner. The story is not of Jewish aggadic provenance, but is of Muslim origin. It is mentioned by az-Zamakhsharī, *Kashshaf*, 1900-1901, vol. 2, p. 373, his commentary on the Qur'ān, while commenting on Sura 28:3. The fire cooled for Moses, as similarly occurred for Abraham and for Daniel's three companions, Hananiah, Mishael and Azariah. In this picture the face of the baby Moses is unveiled. For interpretations of this theme see Gutmann, "Abraham in the Fire of the Chaldeans," in *Frühmittelalterliche Studien* 7 (1973): 342-352, Gutmann, *Hebrew Manuscript Painting*, 1978, Plates 17 and 25, and Basch, *Abraham in the Fire*, 1972.

2. Folio 18 recto, 10.2 x 15.2 cm.

Pharaoh's courtiers present the baby Moses to him. Moses, unveiled, pulls Pharaoh's beard and Pharaoh, suspecting that he is the baby predicted to dethrone him, condemns Moses to death. The angel Gabriel, not shown here, comes to Moses' rescue by guiding his hand to touch a burning coal in order to prove to Pharaoh that Moses is not yet at the age of discernment and cannot, therefore, be held accountable for his actions. The person bearing a brazier of burning coals is visible on the left.

There exist several variations of this story. Ginzberg, *Legends*, 1913, vol. 2, pp. 272ff., states that Moses grabbed Pharaoh's crown and put it on his own head. At least two versions exist in Muslim legendary lore. Aṭ-Ṭabarī, *Ta'rīkh*, 1960-1969, vol. 1, p. 395 and Zotenberg's translation of aṭ-Ṭabarī, *Chronique*, 1867-1874, vol. 1, p. 301, claims, like Shāhīn, that Moses pulled Pharaoh's beard very hard while al-Tha'albī, *Qiṣaṣ al-Anbiyā'*, [n.d.], p. 183, claims that

Moses struck Pharaoh on the head with a small stick. For more information on this motif see also Gutmann, "The Haggadic Motif in Jewish Iconography," in *Eretz-Israel* 6 (1960): 16*-22*.

Netzer, *Muntakhab*, 1973, pp. 23-25.

3. Folio 31 recto, 11 x 15.6 cm.

Moses, unveiled, fights a lion in the desert with his staff. At the bottom of the picture his flock is watching and wild mountain goats are visible on the rocks above. Though we know from Jewish sources that no harm ever came to Moses during his years as a shepherd, no specific combats with animals are mentioned. I was unable to find any Muslim legendary sources for this episode. On the other hand, such an encounter is probably based on similar feats that are *de rigueur* for Iranian epic heroes.

Netzer, *Muntakhab*, 1973, pp. 46-48.

4. Folio 38 recto, 11.5 x 15.6 cm.

During their return trip to Egypt, Moses' wife, Zipporah, circumcises their second son Eliezer (Exodus 4:24-25). Moses is present and veiled, the first such occurence in the manuscript. The veil has "His Excellency Mūsā" and some illegible letters written on it, all in Arabic script, suggesting strongly an awareness of Muslim iconographic *concetti*, if not the actual involvement of Muslim painters. The concept of the veil ultimately goes back to Biblical origins (Exodus 34:35) where Moses must resort to it to communicate with Israel after his encounter with God. The angel (Uriel, Gabriel, Af or Hama(?)) on the left is probably to be identified with the angel who attacked Moses in order to urge Zipporah to circumcise their son (see Ginzberg, *Legends*, 1913, vol. 2, p. 328 and vol. 5, notes 146-149).

5. Folio 70 recto, 10.5 x 15.5 cm.

Moses' uplifted arm and staff cause the split of the Red Sea. According to Jewish tradition twelve paths became visible in the sea, one for each tribe. Moses is shown here leading some groups on three paths. The wall of water is black because the silver used has tarnished (Exodus 14:21-22; Ginzberg, *Legends* 1913, vol. 3, pp. 21f.). Compare the same theme in Rice, *The Illustrations to the World History*, 1976, p. 61.

6. Folio 71 recto, 10.9 x 16.5 cm.

Moses is leading his amazed flock through the Red Sea. Three paths are still visible, conjoining in the center of the

picture. The black water background is again the result of the tarnished silver (Exodus 14:21-22; Ginzberg, *Legends*, 1913, vol. 3, pp. 21f.).

7. Folio 84 recto, 13.1 x 17.2 cm.

During a battle with the Amalekites, Moses conducts the outcome of the fighting by keeping his arms uplifted, guaranteeing a Jewish victory. In this miniature, contrary to the Biblical text or any Jewish or Muslim legend that I have consulted, Aaron and Hur's arms are uplifted as well. (Exodus 17:8-13; Ginzberg, *Legends*, 1913, vol. 3, p. 61). It is interesting to note that they are all unveiled. Compare the same theme in SPK or. oct. 2885, folio 5 verso, no. 1.

8. Folio 102 verso, 11.8 x 16.7 cm.

In heaven, Moses and the angels strive for the Torah. Moses is shown holding the Tablets. It is interesting to note that Moses is unveiled despite, or perhaps because, of his "closeness" to the Divine Presence (Ginzberg, *Legends*, 1913, vol. 3, p. 109ff.).

9. Folio 107 recto, 9.5 x 17.3 cm.

Moses burns the golden calf which looks very much alive, as indeed it was supposed to have shown signs of life (Ginzberg, *Legends*, 1913, vol. 3, pp. 122-123 and vol. 6, notes 266 and 267). The fire is wonderfully vivid as is always the halo surrounding Moses' countenance. The smoke from the fire extends through the top margin of the text (Exodus 32:20; Ginzberg, *Legends*, 1913, vol. 3, pp. 129-130.

10. Folio 131 verso, 9.3 x 16 cm.

Zelophedad, called Aqīl Kīmīyah in the text, is punished by stoning for having desecrated the Sabbath (Ginzberg, *Legends*, 1913, vol. 3, pp. 238-242). I have been unable to trace the origin of the Persian name, Aqīl Kīmīyah.

11. Folio 133 verso, 9.5 x 15.1 cm.

By preventing him from leaving the house, the wife of On saves her husband from being destroyed with Korah's men during their conspiracy against Moses. Korah, the crowned figure on the lower right side, and his companions, are waiting for On outside his house (Ginzberg, *Legends*, 1913, vol. 3, p. 300ff.).

12. Folio 138 verso, 10.1 x 16.8 cm

Korah and his companions in rebellion are being swallowed by the earth. (Numbers 16:32; Ginzberg, *Legends*, 1913, vol. 3, pp. 286-300). The juxtaposition of the pink rocky

ground at the bottom with the aqua rocks in the background is particularly effective. The style of the rocks throughout this manuscript is reminiscent of that of Muḥammad Qāsim (fl. mid-17th century). I am indebted to Professor Stuart C. Welch for this observation as well as for noting that the position of the men in this picture is similar to the way in which the "Seven Sleepers of Ephesus and Their Dog" is usually depicted in Muslim iconography. See, for example, Plate CXXXIII (circa 1550) in Blochet, *Musulman Painting*, 1975. Compare the same theme in Rice, *The Illustrations to the World History*, 1976, p. 63 and in Stchoukine, *Les Peintures*, 1964, Plate XIII (circa 1590).

13. Folio 159 recto, 10.4 x 16.8 cm.

When the Jews complained about their monotonous fare in the desert God sent serpents among them as a punishment. Moses interceded on the people's behalf and was instructed to fashion a serpent of brass, the sight of which instantly healed many of those bitten. The illustration shows only the serpents attacking the people (Numbers 21:8-9; Ginzberg, *Legends*, 1913, vol. 3, pp. 334-336).

14. Folio 181 recto, 9.8 x 15.3 cm.

After Moses killed the giant Og the Jews killed the rest of Og's warriors. Og's gigantic leg, his thigh bone alone was supposed to have been more than three parsangs long, is at the bottom of the picture (Numbers 21:35; Ginzberg, *Legends*, 1913, vol. 3, p. 346).

15. Folio 199 recto, 9.4 x 16.1 cm.

The men who sinned with the women of Moab and worshipped the Moabite idol are executed through God's orders as carried out by Moses (Numbers 25:1-5; Ginzberg, *Legends*, 1913, vol. 3, pp. 380-382).

16. Folio 201 verso, 10 x 16.9 cm.

Phinehas (bottom right) surprises Zimri and Cozbi during their forbidden intercourse and impales them on his lance. Moses' presence in the picture (top right) attests to his tacit approval of Phinehas' deed which, however, he did not witness in the Bible. Two other amazed witnesses are shown in the upper right corner. Phinehas' halo is smaller and less dramatic than that of Moses, attesting to his lower rank in the hierarchy surrounding Moses (Numbers 25:8; Ginzberg, *Legends*, 1913, vol. 3, pp. 386-388).

17. Folio 212 recto, 12.2 x 15.5 cm.

The miniature shows Moses killing Balaam, who is riding his donkey. It was not Moses, however, but Phinehas who

performed this deed. The error may again imply a less knowledgeable, perhaps Muslim, painter (Ginzberg, *Legends*, 1913, vol. 3, pp. 410-411).

18. Folio 242 recto, 9.3 x 15.4 cm.

The angel Azrael comes to claim Moses' life. The name Azrael is the Muslim equivalent of the Hebrew Samael, the Angel of Death. Moses is writing the Ineffable Name [Torah] and the flames issuing from his face and eyes engulf the poorly drawn angel (Ginzberg, *Legends*, 1913, vol. 3, pp. 467-471 and al-Tha'alabī, *Qiṣaṣ al-Anbiyā'*, [n.d.], pp. 262-263).

19. Folio 247 verso, 10 x 15.6 cm.

Moses sees three angels, appearing as men to him, digging a grave. They tell him that it is intended for the "beloved of God" who is about Moses' size. They ask him to enter it in order for them to ascertain the grave's correct size. Once Moses is inside, the Angel of Death buries him. This version of Moses' death is of Muslim origin and was apparently borrowed from Muslim sources by the Falashas (Ginzberg, *Legends*, 1913, vol. 5, note 952). One of the original Muslim sources in which this story is found is aṭ-Ṭabarī, *Ta'arīkh*, 1960-1969, vol. 1, pp. 433-434 and aṭ-Ṭabarī, *Chronique*, 1867-1874, vol. 1, p. 397.

X. Shāhīn's *Mūsā Nāma*

(HUC ms. 2101)

This is a complete manuscript of Shāhīn's epic containing 242 folios and thirty-six miniatures. It is copied on brown or cream pulp paper measuring approximately 27.5 x 18.5 cm. The watermark has a crest with the date 1877. The pages are repaired with Japanese silk paper, having previously been repaired with high acid paper (not brown). The text is copied in black in a fine, even hand throughout. The borders of the miniatures are yellow, blue, green, red, brown and black. The date 1660 is visible under the first miniature, but the watermark as well as the style of the miniatures, mid to late nineteenth century Qājār, indicate the proper era from which the manuscript originates. It is, however, possible that this manuscript was copied from an earlier one that dated from 1660. It is unlikely that it was copied from IM 180/54 because it is substantially different. The Israel Museum copy tends to be more accurate, less colloquial in its phraseology and very often gives *parashah* (Hebrew weekly portions read in the synagogue) headings to indicate the section the poet is setting to verse. The Hebrew Union College copy omits them and adds to most of its chapter titles the phrase "va salām" which is popular folk style. The painting style of the miniatures seems extremely primitive. Of the thirty-six miniatures, twenty-four depict individual combats in almost identical poses, and often the same theme is depicted several times. The epic is discussed and described in Bacher, *Zwei Jüdisch-Persische Dichter*, 1907, pp. 40-43. Part of the epic is edited in Netzer, *Muntakhab*, 1973, pp. 9-58.

1. Folio 3 recto, 15.5 x 13 cm.

Pharaoh ascends the throne. His figure is smudged on the miniature. Under the miniature the date 5 Shevat 5420 (1660) is given in a verse. See above for explanation.

2. Folio 22 recto, 12 x 14.25 cm.

While a shepherd, Moses kills some dragons in the desert. No such feats are recorded in Jewish or Muslim legendary sources, but they are *de rigueur* for Persian epic heroes.

Netzer, *Muntakhab*, 1973, pp. 41-44.

3. Folio 23 verso, 12.75 x 13.75 cm.

In a feat similar to the one above (folio 22 recto, no. 2), Moses kills a winged serpent.

Netzer, *Muntakhab* 1973, pp. 41-43.

4. Folio 24 verso, 5 x 13.75 cm.

Continuing his feats in the desert (see folios 22 recto and 23 verso, nos. 2 and 3 above), Moses kills a lion. Compare with IM 180/54, folio 31 recto, no. 3.

Netzer, *Muntakhab*, 1973, pp. 46-48.

5. Folio 65 verso, 8.5 x 14 cm.

Shown is an individual combat representative of the Jews fighting the Amalekites (Exodus 17:8ff.).

6. Folio 66 recto, 8.5 x 13.75 cm.

Shown is the same subject as folio 65 verso (no. 5 above).

7. Folio 68 recto, 12.5 x 13.75 cm.

Shown is the same subject as folios 65 verso and 66 recto (nos. 5 and 6 above), but the two warriors are identified as Amalek (left) and Joshua (right).

8. Folio 68 verso, 12.5 x 13.75 cm.
This is the same subject as folios 65 verso, 66 recto and 68 recto (nos. 5, 6 and 7 above).

9. Folio 137 verso, 15.75 x 13.5 cm.
The Jews are fighting the Edomites(?). It is not clear who is meant here by Qahār and his hosts, but the events located in the epic between the death of Aaron and the appearance of the fiery serpents seem to imply Numbers 21:1-3.

10. Folio 145 recto, 12.5 x 13.75 cm.
The Jews are waging war against the King of Sihon and his people after their refusal to grant the Jews permission to pass through their land. The warrior falling off the elephant (quite an anachronism for the Biblical tale!) is probably meant to suggest the "otherness" of the Sihonites. Once again, the individual combat is symbolic of the war between the two nations (Numbers 21:24-26; Ginzberg, *Legends*, 1913, vol. 3, pp. 340-342).

11. Folio 145 verso, 12.5 x 13.5 cm.
Shown is the same subject as folio 145 recto (no. 10 above).

12. Folio 146 recto, 11 x 13 cm.
Shown is the same subject as folios 145 recto and 145 verso (nos. 10 and 11 above).

13. Folio 146 verso, 12.5 x 13 cm.
Shown is the same subject as folios 145 recto, 145 verso and 146 recto (nos. 10, 11 and 12 above).

14. Folio 147 recto, 13 x 13.75 cm.
Shown is the same subject as folios 145 recto, 145 verso, 146 recto and 146 verso (nos. 10, 11, 12 and 13 above).

15. Folio 147 verso, 12.5 x 13.74 cm.
Eldad and Muʿabād, two enemies of Israel, are fighting one another. Despite the similarity of names, these heroes are not to be identified or confused with the Biblical and legendary Eldad and Medad of Numbers 11:26-29 (Ginzberg, *Legends*, 1913, vol. 3, p. 251ff. and vol. 6, notes 481-484).

16. Folio 148 verso, 15 x 13.25 cm.
Shown is the same subject as folio 147 verso.

17. Folio 149 verso, 15.25 x 14 cm.
Eldad kills Muʿabād.

18. Folio 151 recto, 10.25 x 14 cm.
Joshua fights Eldad.

19. Folio 152 recto, 13.75 x 13.5 cm.
The same subject as folio 151 recto is shown. The page has been torn in two and two different texts are pasted together.

20. Folio 152 verso, 12.25 x 13.25 cm.
The army of King Sihon attacks Joshua and the Jews. The page has been torn and the bottom half now contains a piece of text that does not belong.

21. Folio 153 verso, 10.75 x 13.5 cm.
The priest Eleazar, son of Phinehas, fights Kuhyār; I could not identify Kuhyār in Jewish or Muslim legendary sources. It is probably the latter who is mounted on the elephant. Needless to say, Jewish priests in the Bible did not usually engage in combat.

22. Folio 154 verso, 16 x 13.5 cm.
Eleazar kills Kuhyār. Again, Jewish priests did not kill.

23. Folio 155 verso, 12.5 x 13.5 cm.
Joshua, with his uplifted sword, personally kills the king of Sihon. I found no Jewish or Muslim sources that note this incident.

24. Folio 157 verso, 13 x 13.5 cm.
Eleazar, accompanied by forty warriors, comes to the aid of Joshua.

25. Folio 158 recto, 14.5 x 13.5 cm.
Joshua continues to fight the Sihonites.

26. Folio 159 recto, 14.5 x 13.5 cm.
The Jews conquer Heshbon, the capital of Sihon. A primitive citadel is visible in the background (Numbers 21:25).

27. Folio 160 recto, 14 x 13.5 cm.
The Jews conquer the kingdom of Amon. The title is misleading as it reads "the kingdom of Bamun", but the content of the chapter reveals the correct identification (Judges 11:32-33).

28. Folio 165 recto, 17.25 x 13.5 cm.
Moses, surrounded by a primitive halo, fights the giant Og (Numbers 21:35; Ginzberg, *Legends*, 1913, vol. 3, pp. 343-348). This miniature is reproduced in black and white in Gutmann, "Judeo-Persian Miniatures," in *Studies* 8 (1968):

57, Fig. 1. Compare the same theme in Rice, *The Illustrations to the World History*, 1976, p. 65.

29. Folio 187 verso, 16.5 x 13.5 cm.
The Jews wreak havoc among the Midianites (Numbers 31:7-8).

30. Folio 190 verso, 12 x 14.5 cm.
A fight between a Jewish and a Midianite warrior.

31. Folio 191 recto, 10.5 x 14 cm.
The same subject as folio 190 verso (no. 30 above) is shown.

32. Folio 191 verso, 10 x 13.75 cm.
The Midianite king Zur is killed by Phinehas (Numbers 31:8).

33. Folio 193 recto, 12 x 14 cm.
Phinehas kills the Midianite king Reba (Numbers 31:8).

34. Folio 194 verso, 11 x 13.75 cm.
The same subject as folio 193 recto (no. 33 above) is shown.

35. Folio 195 verso, 17.5 x 14 cm.
Phinehas kills the Midianite kings Evi, Rekem and Zur(?). This is the claim of the title but we know that King Zur was already killed in folio 191 verso (no. 32 above) and the encounter was depicted as a one-to-one combat (Numbers 31:8).

36. Folio 197 verso, 14.5 x 14.5 cm.
Phinehas kills Balaam (Ginzberg, *Legends*, 1913, vol. 3, pp. 410-414). Compare with IM 180/54, folio 212 recto, no. 17.

XI. Shāhīn's *Mūsā Nāma*

(SPK or. oct. 2885)

This manuscript is an incomplete fragment of Shāhīn's original Judaeo-Persian epic on Biblical themes. It contains seven folios and only one miniature. It is copied on brown paper containing a somewhat spiraly watermark that I was unable to identify. The inner sides of the covers were fitted with marble type paper and the block was restitched. The manuscript was acquired by the Preussischer Staatsbibliothek from a private owner in 1928. It dates, perhaps, from the second half of the seventeenth century.

Based on a close comparison of the calligraphy of this manuscript and the *Mūsā Nāma* of the Israel Museum (IM 180/54) the cataloguer at the Staatsbibliothek Preussischer Kulturbesitz postulates that they were both copied by the same Nehemiah ben Amshal of Tabriz.

The epic is described and discussed in Bacher, *Zwei Jüdisch-Persische Dichter*, 1907, pp. 40-43. Part of this epic is edited in Netzer, *Muntakhab* 1973, pp. 9-58.

1. Folio 5 verso, 14.7 x 9.3 cm.
As mentioned in IM 180/54, manuscript IX, miniature seven, during one of the most important battles between the Jews and the Amalekites, Moses directed the fate of the battle from a hill (Exodus 17:8-13). Whenever his arms were raised the Jews won and whenever his arms fell victory belonged to the Amalekites. Therefore Aaron and Hur helped him keep his arms uplifted while he sat on a rock. The text above the picture indicates that Moses' arms were made to rest on piles of stones, but the painter seems to be confused with the two descriptions. The white triangular formation behind Moses could be a large rock against which he is leaning although it looks more like his cape. In any case, he is neither seated visibly, as the Biblical text would indicate, nor are his arms resting on piles of stones, as Shāhīn's text in the picture claims. Rather his arms are upheld by Aaron and Hur as in the Biblical account. This confusion would, perhaps, indicate a Muslim painter who had been told both the Biblical account and Shāhīn's poetic embellishment of it, but was confused between the details of the two and was unable to consult either text. This miniature is reproduced in black and white in Gutmann, "Judeo-Persian Miniatures," in *Studies* 8 (1968): 61, Fig. 4 and in Schapiro, *Words and Pictures*, 1973, Fig. 14.

XII. 'Imrānī's *Fath Nāma*

(BL Or. 13704)

This manuscript is an incomplete copy of 'Imrānī's epic composed around 1474; reasons for this dating are given in Netzer, *Muntakhab*, 1973, pp. 40-41, which differs from that in Bacher, *Zwei Jüdisch-Persische Dichter*, 1907-1908, p. 167. The author consciously strove to imitate Shāhīn and considered his epic a continuation of the latter's *Mūsā Nāma*. He therefore begins with Joshua. The present copy of the manuscript contains the books of Joshua, Ruth, Samuel I and breaks off after Samuel II, chap. 6. It contains 335 folios and seven miniatures as well as numerous mid-page designs, some of which are noted here. The paper on which it is copied measures approximately 26 x 16 cm. and is white, somewhat yellowed. The manuscript has a new binding and it reached the British Library after having been bought at a Sotheby's sale from the Sassoon collection in Zurich, in November 1975. Several copyists participated in copying the text. Folios 145 verso, 146 recto and 159 verso contain the names of various former Iranian owners, donors and recipients of this manuscript. Since there is no colophon we cannot be entirely certain of the date of its completion. One of the owners (folio 159 verso) notes that he received the manuscript on the first of Nisan 5499 of the Jewish calendar which corresponds to March 9, 1739. Based on the characteristics of the miniatures and this signature of ownership we may safely assume that the manuscript belongs to the very end of the seventeenth or the beginning of the eighteenth century. The epic is described and discussed in Bacher, *Zwei Jüdisch-Persische Dichter*, 1907-1908, pp. 181-195. Part of the epic has been edited in Netzer, *Muntakhab*, 1973, pp. 208-224.

1. Folio 4 recto, two mid-page designs 2 x 3 cm. each

On the left, a crane among red flowers, probably poppies, faces some of these red flowers on the right.

2. Folio 9 recto, two mid-page designs: left 2 x 3.5 cm., right 2 x 3 cm.

On the left, two cranes circling each other on the ground are facing flowers on the right.

3. Folio 15 recto, 22 x 14 cm.

Joshua (top haloed figure) and the priests are carrying the ark across the Jordan river (Joshua 4:18). This miniature is reproduced in black and white in Gutmann, "Judeo-Persian Miniatures," in *Studies* 8 (1968): 71, Fig. 11.

4. Folio 28 recto, two mid-page designs: 3.5 x 3.5 cm., each

A leaping hare on the right and a wild ass on the left are shown.

5. Folio 28 verso, two mid-page designs 2 x 3.5 cm. each

A crane on the left and a crane on the right are quarreling, as it were, across the page.

6. Folio 31 verso, 17 x 13.5 cm.

Seven priests blow the *shofar* (ram's horn) before the walls of Jericho (Joshua 6:20). This miniature is reproduced in black and white in Gutmann, "Judeo-Persian Miniatures," in *Studies* 8 (1968): 72, Fig. 12.

7. Folio 32 recto, 18 x 13.5 cm.

Joshua, riding a white horse and looking old and venerable, is fighting before the walls of Jericho, piercing with his spear the rider of a black horse. Chopped off heads are rolling in the dust.

8. Folio 50 verso, 18.5 x 13.5 cm.

Joshua on horseback, spear in hand, participates in the battle of Ai (Joshua 8:18). This picture, similar in many respects to folio 32 recto (no. 7 above), also has chopped off heads visible on the ground. In the foreground a man is trying to remove an arrow from his rear end just as he is about to be struck by another arrow.

9. Folio 75 recto, 19.5 x 13.5 cm.

Joshua (unfinished figure) riding a black horse, is entering into battle to come to the aid of the Gibeonites (Joshua 10:6ff.). His opponent has a distinctly Chinese appearance. There is an unfinished sketch of a horse in the bottom right corner. Ten horizontal figures are corpses piled on the spear of the warrior in the lower right hand corner.

10. Folio 85 recto, 20 x 13.5 cm.

Joshua, riding his black charger, and his followers defeat the hosts of the king of Mekkedah and his allies. On that occasion five kings were decapitated by the Jews and were hung until nightfall (Joshua 10:26). Only one such figure is shown here hanging in a posture reminiscent of crucifixion. However, the hooks on which the man is hung are more suggestive of the hooks in a butcher shop than of a cross.

The miniature is unfinished with most of the paint still missing. The head of the decapitated king is on the spear of the warrior in the lower right corner.

11. Folio 90 verso, 26 x 16 cm.

A full page sketch of the previous miniature with the hanging figure on the left rather than on the right side shows no traces of paint. There are two animal figures on top.

12. Folio 90 recto, top eight designs 2 x 3.0-3.5 cm., two lower, 4.5 x 3.5cm.

There are ten small flower and animal designs on this folio, five on each side of the page. They are (left): two gazelles, a bouquet of poppies, a hare and a bouquet of unidentifiable flowers. On the other side (right) there are: a leaping gazelle, two bouquets of poppies, a hare, and a bouquet of unidentifiable flowers.

Bibliography

Primary Sources

Album leaves. BL Or. 10194.
'Imrānī. *Fath Nāma*. BL Or. 13704.
Jāmī. *Yūsuf and Zulaykhā*. JTS 1496.
Jāmī. *Yūsuf and Zulaykhā*. JTS 1534.
Niẓāmī. *Haft Paykar*. BL Or. 4730.
Niẓāmī. *Khosrow and Shīrīn*. JTS 1398.
Shāhīn. *Ardashīr Nāma*. JTS 40919.
Shāhīn. *Ardashīr Nāma*. SPK or.qu. 1680.
Shāhīn. *Mūsā Nāma*. HUC ms. 2102.
Shāhīn. *Mūsā Nāma*. IM 180/54.
Shāhīn. *Mūsā Nāma*. SPK or.oct. 2885.
Shu'lah (?). *Yūsuf and Zulaykhā*. JNUL 38°4418.

Secondary Sources

Adler, Elkan N. *Catalogue of Hebrew Manuscripts in the Collection of E.N. Adler*. Cambridge, [Mass.]: University Press, 1921.

Adler, Elkan N. *The Persian Jews, Their Books and Their Ritual*. Oxford: Horace Hart, Printer to the University, 1898. Also in *JQR* 10 (1898): 588-625.

Akimushkina, O.P. and I.A. Ivanova. *Persidskye Miniaturi XIV-XVIIv.v.* Moscow, Akademii Nauka, 1968.

Arnold, Sir Thomas W. *Painting in Islam : A Study of the Place of Pictorial Art in Muslim Culture*. New York: Dover Publications, Inc., 1965.

____. *The Old and New Testaments in Muslim Religious Art*. London: Oxford University Press, 1932.

Asmussen, Jes P. *Studies in Judeo-Persian Literature*. Leiden: E.J. Brill, 1973.

Bacher, Wilhelm. *Zwei Jüdisch-Persische Dichter Schahin und Imrani*. Budapest: Adolf Alkalay & Sohn, 1907 and Strassburg: Trübner, 1907-1908.

Baron, Salo W. *A Social and Religious History of the Jews*, vol. 18. New York: Columbia University Press, 1983.

Basch, Vera. *Abraham in the Fire*. Sr. Thesis. Princeton University, 1972.

Binyon, Laurence, *et. al. Persian Miniature Painting: Including a Critical and Descriptive Catalog of the Miniatures Exhibit at Burlington House January-March, 1931*. New York: Dover Publications, Inc., [1971]

Blieske, Dorothea. *Šāhīn-e Šīrāzīs Ardašīr-Buch*. Ph.D. dissertation. Eberhard Karls University. Tübingen, 1966.

Blochet, Edgar. *Musulman Painting XIIth-XVIIth Century*. Translated from the French by Cicely M. Binyon. New York: Hacker Art Books, Inc., 1975.

Briquet, C.M. *Les Filigranes : Dictionnaire Historique des Marques du Papier des Leur Apparition vers 1282 jusqu'en 1600.* 4 vols. Amsterdam: The Paper Publication Society, 1968.

Browne, Edward G. *A Literary History of Persia.* 4 vols. Cambridge, [Eng.]: Cambridge University Press, 1969.

Chelkowski, Peter J., et. al. *Mirror of the Invisible World: Tales from the Khamseh of Nizami.* New York: The Metropolitan Museum of Art, 1975.

Dickson, Martin B. and Stuart Cary Welch. *The Houghton Shahnameh.* Cambridge, [Mass.]: The Harvard University Press, 1981.

Diyakonova, N.V. *Sredneazyatskye Miniaturi XVI-XVIII v.v.* Moscow: Akademii Nauka, 1964. ,

Djami. *Youssouf et Zouleikha.* Translated by Auguste Bricteux. Paris: Libraire Orientaliste Paul Geuthner, 1927.

Ettinghausen, Richard. *Arab Painting.* New York: Rizzoli International Publications, Inc., 1977.

Fischel, Walter J. "Israel in Iran: A Survey of Judeo-Persian Literature." In *The Jews, Their History, Culture and Religion*, vol. 2. Edited by L. Finkelstein. New York: Harper, 1949.

____. "The Literary Heritage of Persian Speaking Jews." *JWB Annual* 27 (1970): 15-23.

Ginzberg, Louis. *The Legends of the Jews.* 7 vols. Philadelphia: The Jewish Publications Society of America, 1913.

Gray, Basil. *Persian Painting.* New York: Rizzoli Inernational Publications, Inc., 1977.

Grünbaum, Max. *Neue Beiträge zur Semitischen Sagenkunde.* Leiden: E.J. Brill, 1893.

Gutmann, Joseph. "The Haggadic Motif in Jewish Iconogrpahy." *Eretz Israel* 6 (1960): 16*-22*.

____. *Hebrew Manuscript Painting.* New York: George Braziller, Inc., 1978.

____. "Judeo-Persian Miniatures." *Studies in Bibliography and Booklore* 8 (1968): 54-76. Also in *No Graven Images*, pp. 466-488 (see next entry).

____, ed. *No Graven Images: Studies in Art and the Hebrew Bible.* New York: Ktav Publishing House, 1971.

____. "Abraham in the Fire of the Chaldeans : A Jewish Legend in Jewish, Christian and Islamic Art." *Frühmittelalterliche Studien* 7 (1973): 342-352.

The Holy Scriptures. Philadelphia: The Jewish Publication Society of America, 1955.

Jami. *Yūsuf o Zulaykhā.* Kānpūr: Munshī Nūl Kishvār, 1916 (lithograph).

Manuscripts and Rare Books. Exhibition at the Jewish National and University Library, Jerusalem, April-May, 1970.

Martin, F.R. and Sir Thomas W. Arnold. *The Nizami Ms., Illuminated by Bihzad, Mirak and Qasim Ali, Written 1495 for Sultan Ali Mirza Barlās Ruler of Samarqand in the British Museum (Or. 6810).* Vienna: Printed for the author, 1926.

Mayer, Leon Ary. *L'art juif en terre de l'Islam.* Geneve: A. Kundig, 1959.

Moreen, Vera Basch. *Iranian Jewry's Hour of Peril and Heroism: A Study of Bābāī ibn Luṭf's Chronicle [1617-1662].* New York: American Academy for Jewish Research, forthcoming.

____. *Kitāb-i Sar Guzashta-i Kāshān dar bāb-i 'Ibrī va Goyimi-yi Sāni*, forthcoming.

Narkiss, B. *Hebrew Illuminated Manuscripts.* Jerusalem: Keter Publishing House, 1969 and New York: Leon Amiel, 1974.

Narkiss, B. and G. Sed-Rajna. *Index of Jewish Art: Iconographical Index of Hebrew Illuminated Manuscripts.* Leiden: E.J. Brill, 1980.

Netzer, Amnon. "A Judeo-Persian Footnote: Šāhīn and 'Emrānī." *Israel Oriental Studies* 4 (1974): 258-264.

____, ed. *Muntakhab-i ash'ār-i fārsī az āsār-i yahudiyān-i Irān.* Tehran: Chāpkhāna-yi Zībā, 1973.

Nezami di Ganje. *La Sette Principesse.* Translated by Alessandro Bausani. Bari: Leonardo da Vinci, 1967.

Nizâmî. *Le Roman de Chosroès et Chîrîn.* Translated by Henri Massé. Paris: G.-P. Maisonneuve & Larose, 1970.

Niẓāmī. *Kulliyāt-i Khamsa-yi Ḥakīm-i Niẓāmī Ganjayī.* Tehran: Chāpkhāna-yi Sipihr, 1351 (1972).

Rice, David Talbot. *The Illustrations to the World History of Rashīd al-Dīn.* Edited by Basil Gray. Edinburgh: Edinburgh University Press, 1976.

Robinson, B.W. *Persian Paintings in the India Office Library.* London: Philip Wilson for Sotheby Parke Bernet Publications, 1976.

____. *Persian Miniature Paintings from Collections in the British Isles.* London: Her Majesty's Stationary Office, 1967.

____. *Persian Drawings: From the 14th Through the 19th Century.* New York: Shorewood Publishers, Inc., 1965.

Schapiro, M. *Words and Pictures: On the Literal and the Symbolic in the Illustration of a Text.* The Hague: Mouton, 1973.

Stchoukine, Ivan. *La Peinture Iranienne sous le derniers 'Abbâsides et les îl-Khâns*. Bruges: Imprimerie Sainte Catherine, 1936.

____. *Les Peintures des Manuscrits Timurides*. Paris: Libraire Orientaliste Paul Geuthner, 1954.

____. *Les Peintures des Manuscrits Safavis de 1502 à 1587*. Paris: Libraire Orientaliste Paul Geuthner, 1959.

____. *Les Peintures des Manuscrits de Shah 'Abbās Ier à la fin des Safavīs*. Paris: Libraire Orientaliste Paul Geuthner, 1964.

____. *Les Peintures des Manuscrits de la "Khamseh" de Nizâmî au Topkapi Sarayi Müzesi d'Istanbul*. Paris: Libraire Orientaliste Paul Geuthner, 1977.

____. "Notes sur des Images de l'École d'Isfahan de la fin du XVIe et du XVIIe siècle," reprinted from *Syria* 48 (1971) 1-2. Paris: Libraire Orientaliste Paul Geuthner.

Striedl, Hans. "Die Miniaturen in einer Handschrift des jüdisch-persischen Ardašīrbuches von Šāhīn." *Forschungsberichte* (Forschungen und Fortschritte der Katalogisierung der Orientalischen Handschriften in Deutschland. Edited by W. Voight) 10 (1966): 119-133.

aṭ-Ṭabarī, Abū Ja'far Muḥammad ibn Jarīr ibn Yazīd. *Chronique*, vol. 1. Translated by M. Herman Zotenberg. Paris: Imprimerie Imperiale, 1867-1874.

____. *Ta'rīkh al-rusul wa'l-mulūk*. Edited by Muḥammad Abū'l Faḍl Ibrāhim. 10 vols. Cairo: Dār al-Ma'ārif, 1960-1969.

al-Tha'labī, Aḥmad ibn Muḥammad ibn Ibrāhīm Abū Isḥaq al-Nishāpūrī. *Qiṣaṣ al-Anbiyā'*. Cairo: Maktabat al-Jumhuriyyah al-'Arabiyyah, [n.d.]

Uchastkina, Z.V. *History of Russian Hand Paper-Mills and Their Watermarks*. Vol. 4: *Monumenta Chartae Paypraceae Historiam Illustrantia*. Hilversum, Holland: The Paper Publication Society, 1962.

Wahīd, Muḥammad Ṭāhir Qazvīnī. *'Abbāsnāma*. Edited by I. Dehgan. Arak: Chāpkhāna-yi Farvadī, 1951.

Welch, Anthony. *Artists for the Shah: Late Sixteenth-Century Paintings at the Imperial Court of Iran*. New Haven & London: Yale University Press, 1976.

____. *Imperial Mughal Painting*. New York: George Braziller Inc., 1978.

____. *Wonders of the Age: Masterpieces of Early Safavid Painting, 1501-1576*. Cambridge, [Mass.]: Fogg Art Museum Harvard University, 1979.

Wust, E. "Yaduhei Iran va Sifrut Farsit - Iyyunim bi-Kitvei Yad." *Kiryat Sefer* 58 (1983): 605-621.

Yarshater, Ehsan. "Some Common Characteristics of Persian Poetry and Art." *Studia Islamica* 15 (1962): 61-71.

az-Zamakhsharī, Maḥmūd ibn 'Umar. *al-Kashāf 'an ḥaqā'iq at-tanzīl*, vol. 2. Cairo: Būlāq, 1900-1901.

Bibliographica Judaica 9

A bibliographic series of the Library of
Hebrew Union College-Jewish Insitute of Religion
3101 Clifton Avenue, Cincinnati, Ohio 45220

1 Rudolf Glanz. *The German Jew in America.* An Annotated Bibliography Including Books, Pamphlets and Articles of Special Interest. 1969
2 *Judaica.* A Short-Title Catalogue of Books, Pamphlets and Manuscripts Relating to the Political, Social and Cultural History of the Jews and to the Jewish Question, in the Library of Ludwig Rosenberger, Chicago, Illinois. 1971
3 Bernard Grossfeld. *A Bibliography of Targum Literature.* 1972
4 *Judaica.* Supplement [to No. 2 above]. 1974
5 Werner Weinberg. *How Do You Spell Chanukah?* A General-Purpose Romanization of Hebrew for Speakers of English. 1976
6 Martin H. Sable. *Latin American Jewry: A Research Guide.* 1978
7 Shimeon Brisman. *A History and Guide to Judaic Bibliography* (Jewish Research Literature, Vol. 1). 1977
8 Bernard Grossfeld. *A Bibliography of Targum Literature.* Volume Two. 1977
9 Vera Basch Moreen. *Miniature Paintings in Judaeo-Persian Manuscripts.* 1985
10 Nahum Waldman. *The Recent Study of Hebrew: A Survey of the Literature with Selected Bibliography.* Forthcoming.

Microfiche Guide

	1	2	3	4	5	6	7	8	9	10	11	12
A	I,1	III,2	III,2A	III,3	III,7	III,9	III,10	III,11	III,26	IV,3	IV,6	IV,11
B	V,1	V,2	V,5	V,5A	V,6	V,6A	V,7	V,11	VI,1	VI,2	VI,4	VII,2
C	VII,3	VII,4	VII,5	VII,6	VII,7	VII,8	VII,9	VII,10	VII,12	VII,16	VII,17	VII,18
D	VII,19	VII,21	VII,22	VII,23	VII,24	VIII,4	VIII,4A	VIII,4B	VIII,9	VIII,12	VIII,13	VIII,28
E	VIII,28A	VIII,29	VIII,29A	IX,1	IX,2	IX,3	IX,4	IX,5	IX,6	IX,7	IX,8	IX,9
F	IX,10	IX,11	IX,12	IX,13	IX,14	IX,16	IX,18	IX,19	X,3	X,9	X,17	X,24
G	X,27	XI,1	XII,1	XII,3	XII,5	XII,7	XII,8	XII,9	XII,10	XII,11	XII,12	

Roman numerals refer to the manuscript numbering within this catalog; Arabic numerals refer to the miniatures within each manuscript.